Jodi Ohl

abstracts
in acrylic & ink

NORTH LIGHT BOOKS
CINCINNATI, OHIO
www.artistsnetwork.com

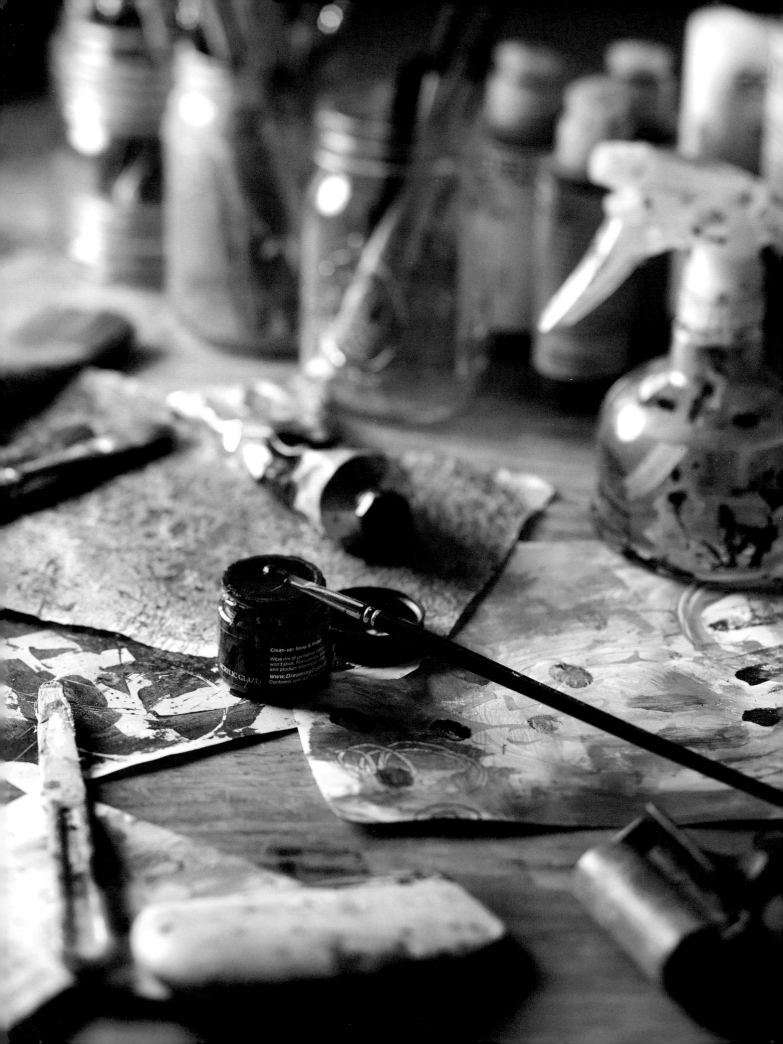

contents

FOR YEARS I'VE BEEN DABBLING IN ABSTRACTS.
Happily moving paint around the canvas. Scratching into the layers of paint and texture. Writing my thoughts down for the day on a layer that will be veiled by more paint, perhaps covered by a piece of paper. There have been days when I work and I see nothing but a hot mess. Colors that do not go together and a lack of direction with no foreseeable end in sight. I walk away confused and a bit frustrated, yet I almost always walk away happy.

How can one be happy yet frustrated? It's like having a dynamic conversation with enthusiastic participants. The more passion each side has, the more interesting the dialogue is. Does there have to be a winner or loser in the dialogue? Do you have to come to a conclusion that everyone is happy with? Or is it good enough to simply talk and have your feelings heard by another person?

Introduction

I say this because painting can be like having a passionate dialogue between yourself, your paint and the canvas. The three of you work together back and forth. There are moments when you get so lost in what you are saying to one another, you hardly can believe two or four or eight hours have passed. You have experienced extreme highs when the flow seemed to pour out of you and then there were moments when you had to walk away from the "argument" before you punched something or someone.

At the end of the day (or the session), a resolution of all the players occurs. You come to an acceptance of one another's belief systems. Everyone has had a chance to be heard and you are all at peace with what has transpired. You've detached yourself from the outcome but had a vested hand in what transpired from the moment you started "talking." It's no longer yours, hers, theirs, his. The painting has become its own persona. You gave birth in a sense.

That relationship, the dialogue, the argument, the love, the frustration, the acceptance, the letting go, it's all in the painting. It's a happy moment yet it's a frustrating moment. You can't always control what you create, just like you can't control another person, but if you are lucky, the best parts of you have influenced this "being" into becoming a bit better than it could have had you not been in its life. That's all we can ask for no matter what we do.

When I thought about writing a book on abstracts, I rejected the idea, thinking I have absolutely no right to be an author on abstracts, painting or any other artistic endeavor. I've never attended art school (other than a few long-forgotten drawing classes in high school and college). I am not a graduate with a MFA, nor do I know all of the so-called "rules" of painting. The fear of writing about something you are not an expert on is so real, it can be paralyzing. Truthfully, the fear of attempting anything you are not confidant about can be paralyzing. Yet, if we all did only what we have mastered, what would any of us do? I think the better way to look at my right to write about abstracts, or art in general, is that I am sharing my experience with you, and if you stick with me, five years from now I'll have new experiences to share. If we all keep trying new things, the world will be a much richer place. The bonus points come from birthing creations (our paintings) into the world, objects that would not exist had we not stepped away from our fear and walked through the door of opportunity.

Don't let the fear of not being ready or not knowing enough stop you from doing what is in your heart or trying something you are drawn to. There's a reason for it all, and it's about to unfold. We all have a sweet and humbling connection to one another. We all start at the same place, the beginning. Life, if we let it, will constantly show us what we need to learn.

That is why I should write a book on abstracts, even though I have had no formal training. The result is a book about learning how to unfold, learn, grow, expand, experiment and experience a dialogue with your art.

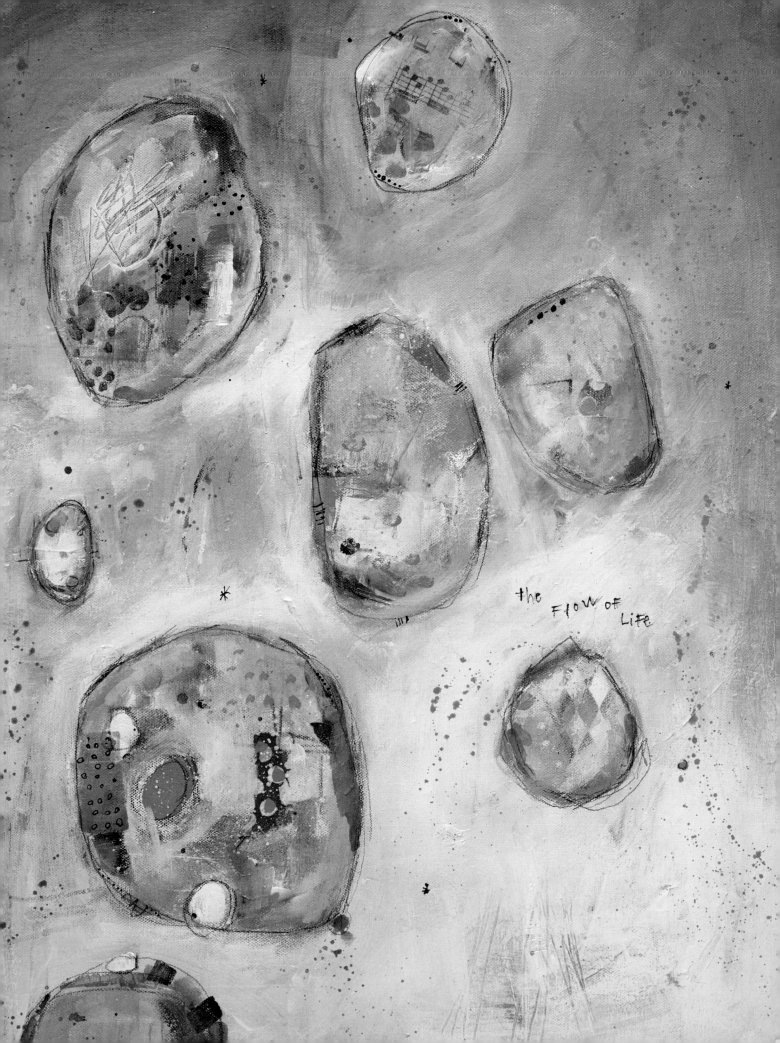

the FLOW OF LIFe

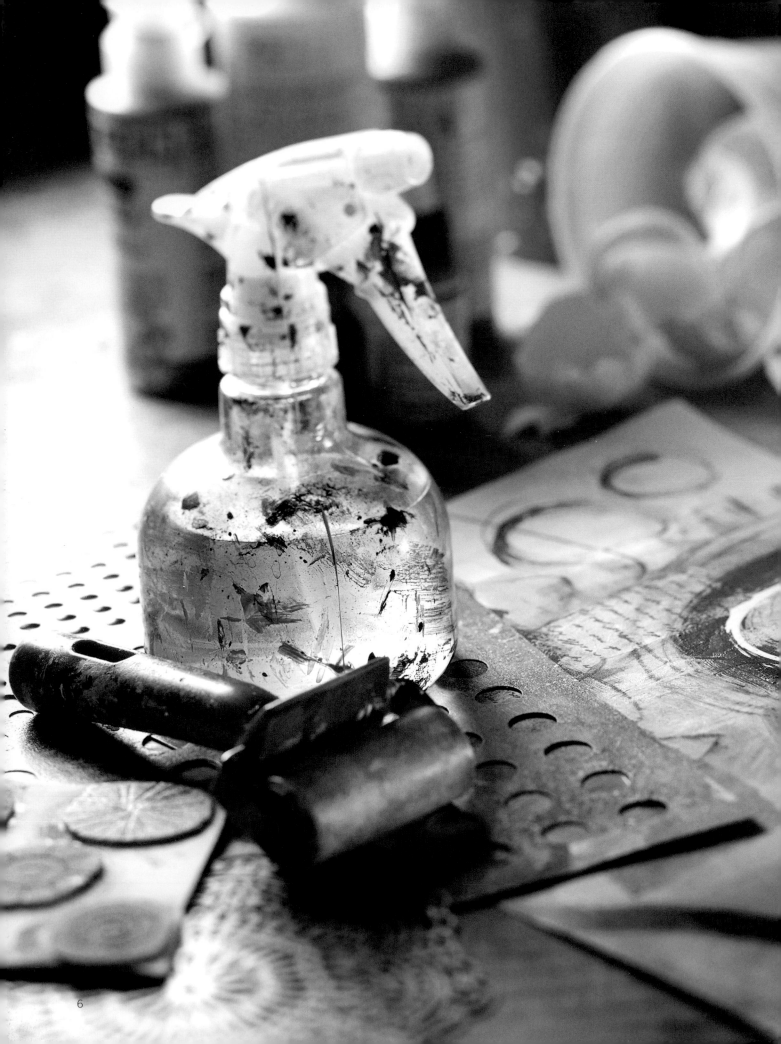

Supplies and Creative Inspiration

WHEN I LOOK AT BOTH my home studio and my working studio (yes, I have two studios!), it's hard to believe how many supplies I'm surrounded by now. In 2006, when I first started painting, journaling, collage work and overall dabbling in mixed media, I could fit all the supplies I owned on a medium-sized decorative shelf ladder, along with a few assorted stamps, pens, papers and brushes I kept on my desk. Just like most art supply "collectors" (and I do say that word loosely as there is a fine line between collector and hoarder), I find it hard to resist whatever is calling me at the moment. Whether it's the thrill of a shiny new paint color or a brush that promises master pieces at the end of the stroke, it's hard to say no.

Over time, though, I have developed an appreciation for higher-quality supplies and professional-grade materials. After disappointments with canvases that warped after I painted for hours on them, paints that appeared dull or cracked because of too much water and impure binder in their formulas, bristles falling out and becoming part of my painting, it goes without saying that some of the frustration experienced could have been avoided if I had invested a little more in my craft.

Here's the contradiction I will pose for you: You don't need to buy the best products if you are new to painting. It's like if you were just starting to sew and weren't even sure if you were going to enjoy the process, you more than likely wouldn't buy the best sewing machine on the market right out of the gate. Rather, you'd start with one that was affordable and good to practice with and then upgrade after you were fairly certain you would stick with the medium. With that in mind, buy a few key colors (your primaries for example), and learn to mix those colors. In the next few pages, I'll share information and tips about typical supplies we will be using. Hopefully for those that are new to painting, they'll help you make better decisions as to what to add to your artistic arsenal.

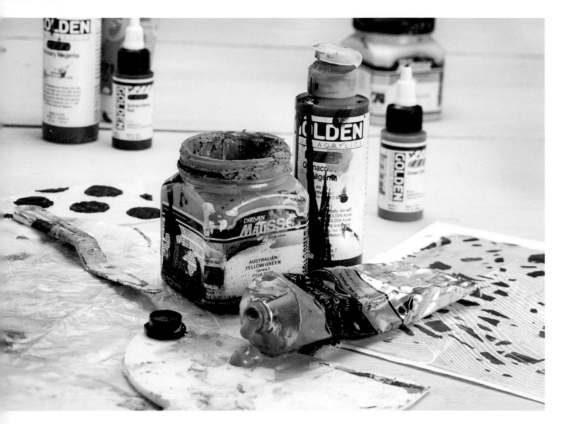

Paints

Acrylic paints typically come in a few different levels of viscosity: flow, fluid, soft body, heavy body or impasto. Each of these styles of paint results in looks that are slightly different from one another. If you prefer a thin water media approach to acrylic painting, flow or fluid are good choices. If you want more coverage and easy blending, soft body does the job. If your painting calls for brushstrokes to come through and peeks of paint to keep their form, heavy body or impasto fit the bill. My favorite paints are definitely Golden Artist Colors. I use them in virtually every painting I create. Along with Golden, other great choices include Matisse, Liquitex and Charvin.

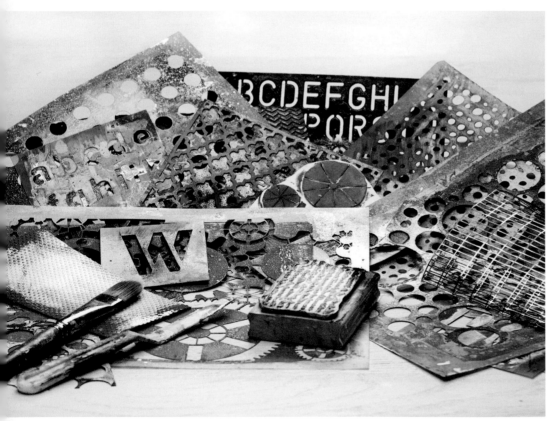

Stencils and Stamps

If you haven't yet discovered how versatile stencils are in your art repertoire, run to your nearest art supply store or online supplier and grab a few! I use them for background patterns, textural elements and to add to the design of my compositions in countless ways. When printing, especially, stencils and stamps offer easy and unique ways to construct interesting patterns and designs. Commercially made stencils are so well made and affordable it's easy to see why artists have made them a staple in their toolboxes. There are many tutorials available online or in a variety of books, which can show you how to make your own stencils or stamps, if you would rather have marks that are uniquely your own.

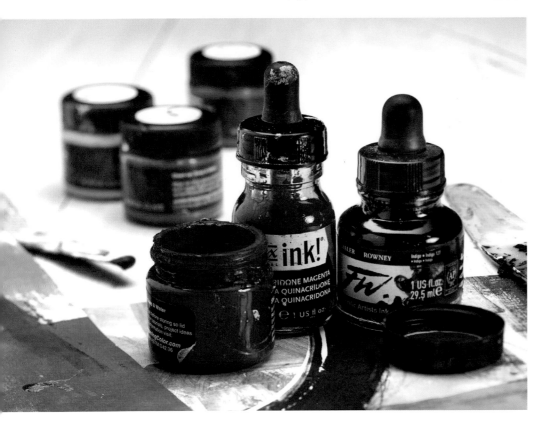

Inks and Glazes

For quick brilliant color, inks provide a sheer or semiopaque, thin coverage that is perfect for use as base stains or under paintings, drips, pours and splatters. Use ink in a fountain or dip pen to create line work or use it with a thin brush to draw on your details. I love using glazes for applications over the top of my paintings or for use in my Claybord paintings, as you'll see in subsequent chapters.

Brushes

When faced with the plethora of brushes available for acrylic painting, it's no wonder artists and students are confused. First and foremost, steer clear of the twenty-brush packs for ten dollars. Not only will bristles land in your paint, your brushstrokes will be inconsistent and very hard to blend or shape cohesively. Choose brushes that are appropriate for the size of your project. A large brush should be a staple in every artist toolbox for painting on substrates bigger than 12" × 12" (30cm × 30cm). Include a few flats, rounds and angled brushes as well. You'll also need a fan brush along with a brayer. Size and brand are personal choices. I have found the Creative Mark brushes a good synthetic option at affordable prices.

Scrapers and Mark-Making Tools

Using silicon scrapers or even old credit cards to apply paint in a textural way has become one of my favorite methods of paint application and reduction. Palette knives are key tools for mixing paint, applying color for a more gestural and organic look, as well as scraping or pulling back layers. Add a few scrapers to your collection and experiment with the many ways you can utilize mark-making tools in your work, abstract or otherwise.

Writing and Drawing Tools

As a mixed-media artist at heart, I feel that practically everything is fair game for use in my paintings. Most of the time I include all of these supplies listed, along with gel mediums and drawing tools in my work. Water-soluble crayons and pencils, charcoal, graphite, paint pens, markers, India ink pens and gel pens are just some of the options I find useful for adding details, sketching compositions, shading, highlighting and of course, mark making

The Odds and Ends

All artists will have their favorite odds and ends they can't live without in addition to the more common supplies used. My favorite extra tools include a spray bottle, heat gun, sponges, drawing paper, journals, and perhaps the most commonly used, deli paper. I use deli paper for printing and scraping techniques, as collage substrates, for barrier layers when affixing paintings to wood substrates, and more. You can find it at most restaurant supply companies online or through Amazon.

Demystifying Mediums

MEDIUMS CAN BE MIND-BOGGLING to the beginner and even to the more seasoned painter. Books are dedicated to their usage and application. At the core, think of mediums as paint without color. They are the binder that acrylic paints are essentially made of. Ranging in thickness, sheen, translucency and textural make up, mediums can add virtually any effect you desire to your work. Some keep your paint open longer, others add a leveling effect to a fluid paint, and still others act as adhesive for your collage.

If I had to choose only five mediums to add to my collection I would pick: gesso, a fluid matte medium, a matte or semigloss gel medium, a glazing medium and a modeling paste. The rest are great to have, but you can get by without them. Think of them as spices to add to your cabinet as you become more and more familiar with your craft. They can elevate your work, but if they aren't going to be used often, it isn't wise to spend your money on them.

Let's discuss some of the more commonly used mediums:

Fluid Mediums affect the sheen and the viscosity of your paint. For example, mix fluid matte medium with a gloss paint and it will thin down your paint in addition to reducing the glare from the gloss.

Gel Mediums also range in the sheen available from matte to semi-gloss and gloss, they can be used to increase the thickness of your paint. Gel mediums are like soft butter, whereas fluid mediums resemble a thin syrup. Gel mediums also work great as collage adhesives.

Glazing Medium is used to extend acrylic paint and to allow for more open time, as well as to create translucent finishes or glazes. To protect a paint's integrity, mix glazing medium into your paint to thin the paint rather than water. Too much water added to an acrylic paint can result in the film not properly formulating, which can cause peeling or cracks on the surface.

Textural Mediums range from modeling paste in a variety of thicknesses to mediums with additives such as sand and stone. This category of mediums can add some interesting effects in your work. For example, you could choose to lay down crackle paste to simulate a worn and weathered look, or you might add modeling paste to create an opaque surface coverage similar to plaster but more flexible and suitable for working on canvas.

Leveling Gels such as Tar gel, pouring medium and self-leveling gels are fun mediums to mix fluid acrylics in to create Jackson Pollock-like drips, marbling effects and smooth high-gloss coverage without crazing. Leveling gels also range in viscosity. Tar gel has a thick, honey-like consistency, compared to the thinner syrup thickness of pouring medium or self-leveling medium.

About Creativity

"Creativity is inventing, experimenting, growing, taking risks, breaking rules, making mistakes and having fun."
— MARY LOU COOK

Surfaces and Papers

Stretched Canvas is probably the most popular surface to use for acrylic painting techniques. When choosing a stretched canvas for your project, you must consider the weight of the canvas and the profile (depth) of your surface. If the material is too thin you will risk puncturing the surface with aggressive painting and collage techniques. With large canvases, I recommend thicker profile stretcher bars, as thinner bars tend to warp easily if they are stored improperly or if heavy loads of paint and collage have been applied.

Wood, or wood-like surfaces, is what I find myself reaching for more and more these days because of its strength and durability. Wood holds up well to all sorts of gel medium and collage techniques. I encourage you to try surfaces such as Gessobord, Hardbord and Claybord. Each substrate lends a slightly different effect to the overall painting.

Don't be afraid to try a variety of surfaces. I guarantee new doors will open in your painting repertoire if you step outside of your creative routine.

Paper Types are plentiful. Whether you are diving into a full day of creating prints for collage elements or using paper as the main substrate for your work, you'll find many options to choose from. Some of my favorite papers include watercolor paper, mixed-media printing paper, Yupo paper and Dura-Lar paper. For quick printing sessions, anything goes—grab some copy paper or old scrapbook paper and you are ready to create unique painted papers for use in your paintings.

WHEN I FIRST DECIDED to include this section in the book, I intended to show you a range of pictures that exemplified exactly where inspiration can be found, but it really didn't come together for me. The more I thought about it, the more I realized that inspiration is so personal to each artist, it's hard to point out where to find one's muse. There's not a road map to becoming an inspired artist, but if you are an artist, you are already inspired and passionate about what you do. Isn't that right?

How to keep that inspiration flowing and what to do when it's not coming together are perhaps the better questions to pose and/or discuss. I know for me, it's all about keeping my eyes and ears open to

Understanding Why You Paint and Where Inspiration Can Be Found

digest the world around me. Keeping a notebook and journal is the easiest way for me to catalog the sources of inspiration, experiment with tools and to wind down at night. Both serve as reference points for me when I am at a loss as to what to do. A song I hear may spur a story in my head. A smell of my favorite meal may bring me back to a time and place that emotes peace and love. Walking on the beach can clear my head and soothe my soul. Leafing through a home decorating magazine may inspire a new color palette for my next collection. Taking my camera wherever I go is a fact of life these days—I rarely leave home without it, and if I do there's always the phone camera to turn to.

The point of this ramble is that finding and keeping what inspires you at the top of your priorities list is probably one of the most important self-care tasks you can do as an artist. Without inspiration, you become an empty vessel void of anything to pour on the canvas.

If your well is dried up and you find yourself stuck in a quagmire of self-doubt, fear, or uncertainty of what to do next, it is more than likely time to take a break. Get some sleep. For me, a lack of R&R time is one of the biggest reasons I fall into an uninspired abyss. Once I take care of myself, I find the flow to come more naturally. In addition to general self-care, creating a practice ritual in the studio—where you show up and forge through any fears of getting started—can prove invaluable. That practice ritual may look different to each person, the same way everyone's start to the day varies slightly. One thing I do most days is to leave my table with the next project ready to go. Doing so can help to jump-start your painterly routine. As I mentioned before, art journaling is one way to keep an ongoing source of inspiration at your fingertips. Art journaling can also be a great relaxer for those days or evenings when you don't have it in you to take out all of your supplies.

Lastly, listen to your intuition and allow it to guide you. Listen carefully, and you will know what you need to become inspired again. Why did you start painting in the first place? What is it that makes your heart sing? Be true to that calling and allow it to flow freely and without constraints.

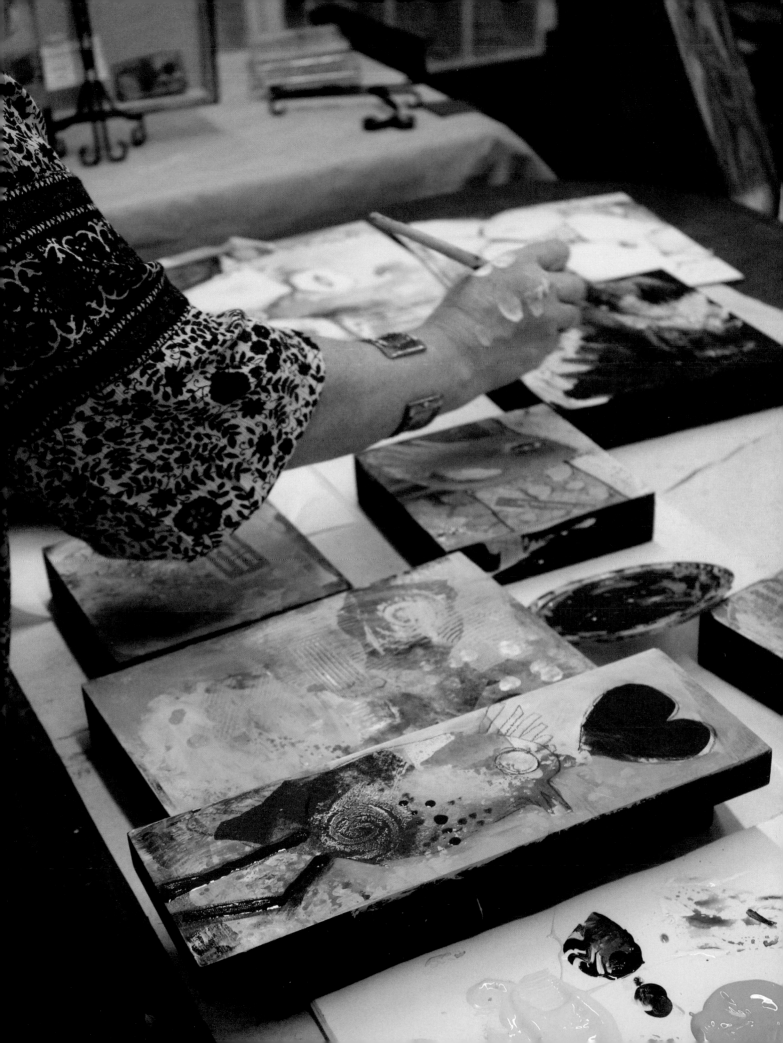

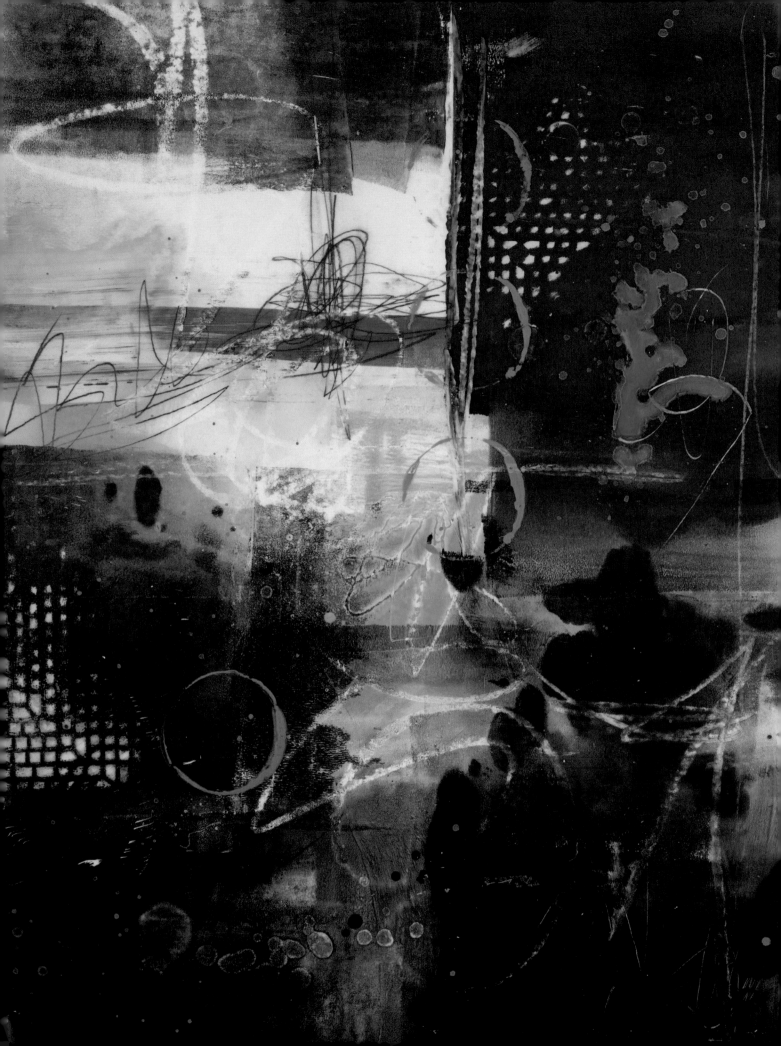

1 Getting Started and Building Your Knowledge

WHILE THERE ARE MANY APPROACHES on how to get started painting abstract art, my philosophy is to simply start. In this chapter you will be offered different warm-up exercises that will hopefully inspire you to jump in with both brushes, as well as experiment with new surfaces. With these quick and loose exercises, you will begin to build a library of ideas, color palettes, patterns and designs you can incorporate in future paintings. My goal in this chapter, and throughout the rest of this book, is for you to dive in with an open mind and fearless heart. You'll find you produce many more masterpieces when you develop a healthy practice of doing your art as often as possible. What are you waiting for? Grab your paints and get busy!

About Building Your Knowledge

"I did then what I knew how to do. Now that I know better, I do better."

— MAYA ANGELOU

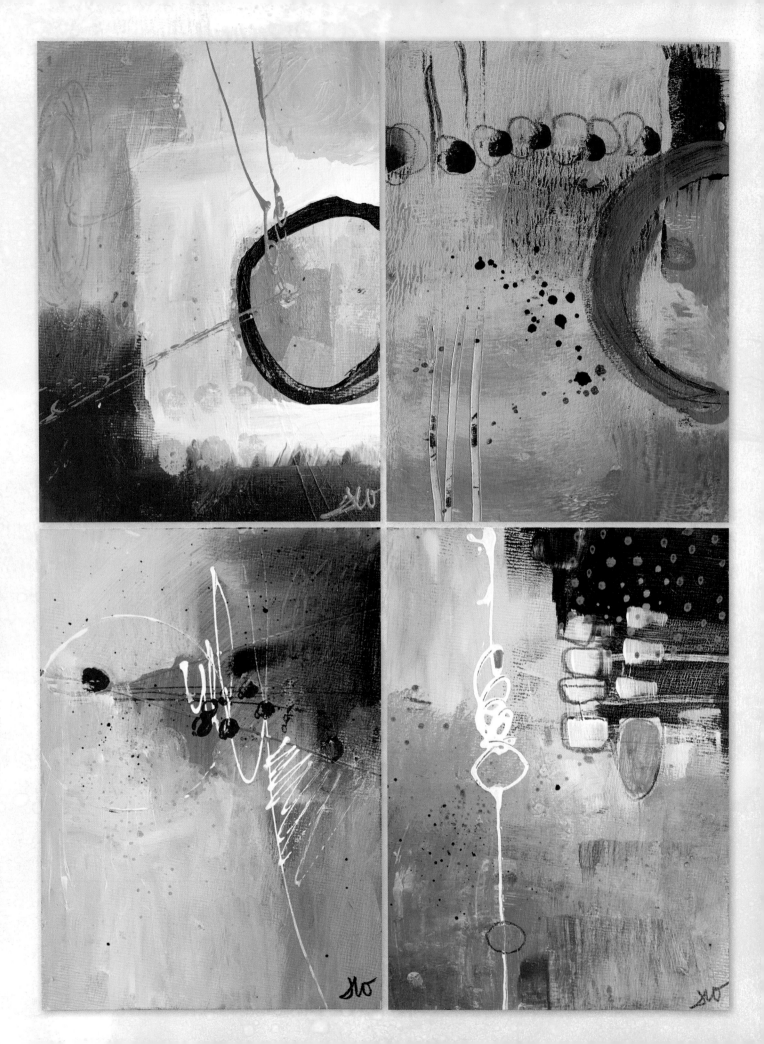

Working Fast and Small

Materials list

2–3 small to medium flat brushes

3–4 acrylic colors plus black and white soft body paint

Bottle lid

Brayer

Gesso

Jerry's Jumbo Jet Black pencil

Matte board or artist tiles

Paper towels

Soft foam brayer

Spray bottle with water

FOR MYSELF AND MY STUDENTS, I have found that getting started is perhaps the hardest part of any painting session. Whether that difficulty is derived from worrying about "ruining" an expensive canvas, or not knowing exactly what to do once you're ready to begin, any number of reasons might stop one from laying that first brushstroke onto the surface.

In this first demonstration, we are working with an inexpensive surface (matte board). The point is to create fast and small. In fact, set a timer for ten to fifteen minutes so that you are challenged to make quick decisions as you lay down your design. Learning to trust your instinct is a skill that builds over time. You'll gain confidence from this low pressure practice.

1 Prep Boards With Gesso

Set a timer for ten to fifteen minutes so that you aren't tempted to overwork your pieces. Take out three matte boards or tiles and apply a thin layer of gesso to the surface.

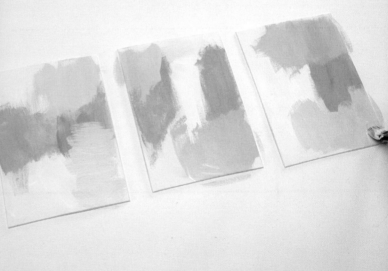

2 Start to Build Up Colors

Add your first color to each tile randomly. Try to do something different on each surface. Mix some white acrylic into the paint to vary the values of your hues.

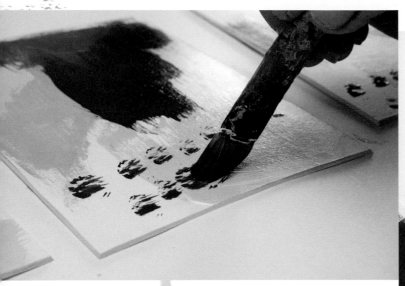

3 Bring In a New Color

Add a new paint color. Overlap the colors and add patterns or textures with your brush. You may want to turn your surfaces while doing this to generate new ideas and a fresh perspective.

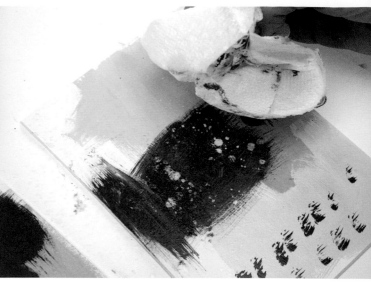

4 Pull Up Sections of Color

While the paint is still tacky, spray a bit of water on the surface. Allow it to sit for a minute, then gently remove with a paper towel to reveal the surface underneath. Continue adding colors on each surface.

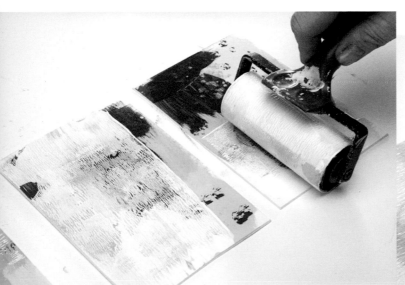

5 Roll on White

Using a brayer, add a layer of soft body white to each surface. Leave some open areas.

6 Scratch Into the Surface

Using the back of your brush or pen, incise the wet paint to create scratchy lines and texture. Continue building up the layers quickly, adding more paint as desired.

7 Stamp on Black
Add a touch of black for contrast. Use a bottle lid (or stamp/stencil) and paint the edges in black. Stamp onto the surfaces of each tile.

8 Add Paint Splatter
Load a moist paintbrush with a bit of paint and tap on it to make paint splatters. Choose a color you want to draw attention to or add as a contrasting color.

9 Add Scribbles and Lines
Using a Jerry's Jumbo Jet Pencil, quickly scribble random lines and patterns onto the surface.

10 Paint With Your Fingers
Try painting with your fingers to blend and add shapes to your pieces. Repeat these steps until the timer goes off. The key is not to overthink the process and just to work fast and small.

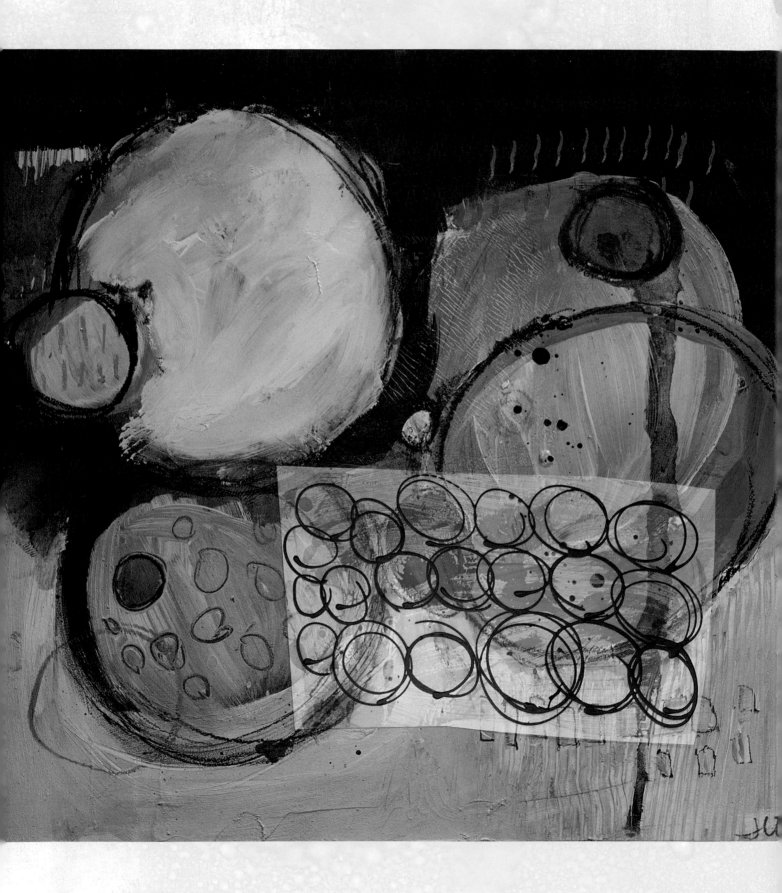

Demonstration

How to Move Past the Blank Canvas

NOW THAT YOU'VE HAD SOME PRACTICE working fast and small, it's time to kick the fear of the blank canvas aside using your small pieces as inspiration. A large part of abstract art is setting aside your fears or preconceived notions of how something is supposed to look and just diving in. There's time to worry about design and composition later as the painting comes together. For this demonstration limit your color choices so you're not overwhelmed with options. Choose a cool or warm color palette. I'll introduce a few new tools and supplies that you'll use throughout the lessons in each chapter. Here are some simple words of advice to ponder: don't fear a blank canvas…it's just a canvas!

Materials list

20 gauge Fineline applicator filled with black fluid acrylic paint

Ampersand gessobord

Assorted acrylic paints: Titanium White, Quinacridone Magenta, Teal, Golden High Flow Diarylide Yellow

Brayer

Deli paper

Dura-Lar wet media film

FW Acrylic Ink Scarlet

Gesso

Neocolor II crayons

Scraping tools

Soft black pastel

Soft body gel medium

Spray bottle

Stabilo All Pencil in black

1 Draw Shapes With the Fineline Applicator
Using a Dura-Lar wet media clear sheet and a Fineline applicator filled with acrylic paint, cover the entire sheet with a variety of doodles. Use a gentle touch with the applicator bottle. Angle the bottle low to the surface so you have more control over your lines. Set aside to dry.

2 Scribble Onto the Gessobord
On an Ampersand gessobord, scrape a dollop of gesso onto the surface. While the board is still tacky, draw scribble lines using a Stabilo All Pencil. Don't press too hard or the pencil will blend quite a bit when you paint over the lines. Add a touch more gesso over a segment of lines so a portion of the marks recedes into the background.

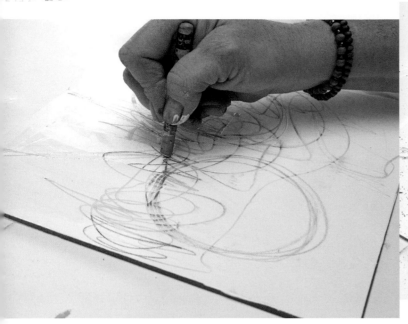

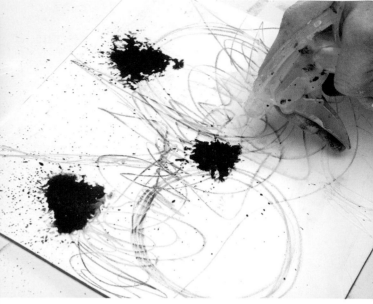

3 Pull Out Shapes
Use a crayon to pull out some shapes from your doodles and scribbles. If you don't see obvious shapes, create some!

4 Drop In Ink
Drop a few dots of acrylic ink onto the surface. Spray a little water onto the ink blots to encourage the ink to bloom. If desired, tilt the surface so the ink runs slightly. Allow the painting to dry for a few minutes before moving on, or blot excess ink with a paper towel.

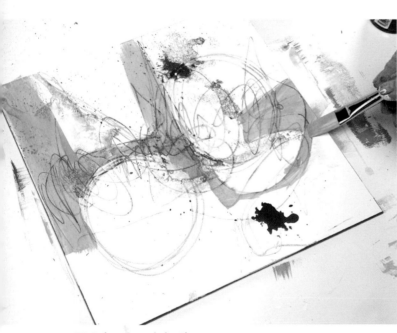

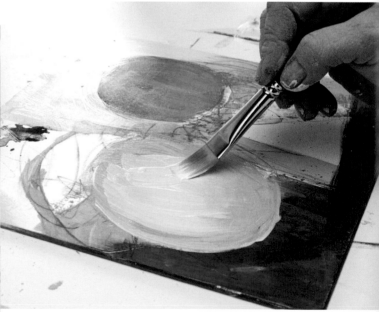

5 Paint Around the Shapes
Using Golden's high flow acrylic, brush the paint around shapes you identify. Vary the size of the areas you are painting. Play with the shapes you've created and let them guide you as you work your way around the surface.

6 Build the Layers
Continue to develop the painting by adding acrylic paints and inks, but try to limit your palette to just a few colors.

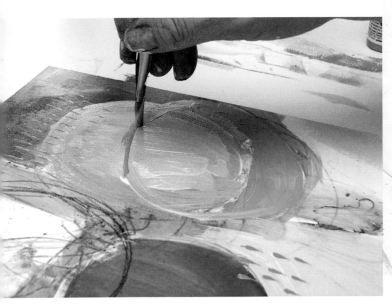

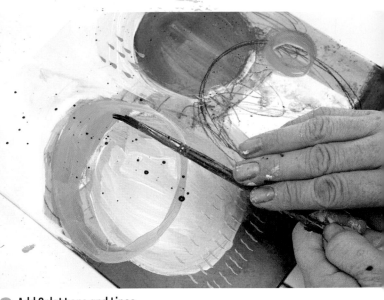

7 Define the Shapes and Build the Layers

At this stage, try redrawing your lines or shapes using a pencil or pastel. Continue building up the layers of paint color as you discover new shapes.

8 Add Splatters and Lines

Add paint splatters and simple lines such as dots, dashes, circles or scribbles with your crayon, pencil or paint.

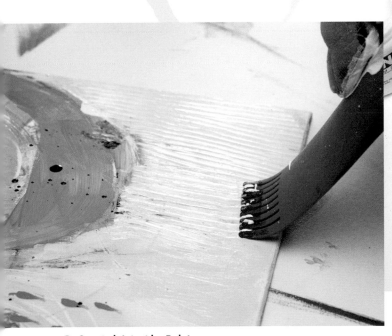

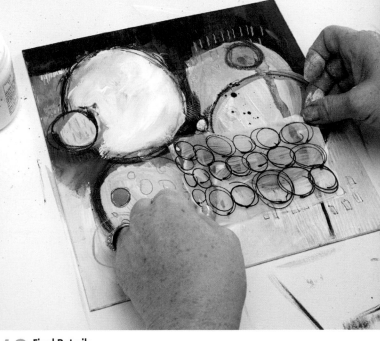

9 Scratch Into the Paint

Use a scraping tool (I used a catalyst blade) to scratch into the wet paint.

10 Final Details

Darken the edges of the shapes with your choice of drawing medium. Use your fingers to smudge the edges so the shapes pop with definition. Once the surface is dry, cut a segment of the doodled transparent sheet you created in Step 1. Ensure that the sheet is completely dry before using it. Apply your collage element to the surface with soft body gel medium.

To secure the collage piece, use a piece of deli paper over your transparency after you've applied the gel medium. With a brayer or your fingers, roll over the collaged paper starting from the center and working to the outside edge.

Using Yupo Paper to Create Backgrounds

YUPO PAPER IS ONE OF MY FAVORITE SURFACES to use in my abstract adventures. Interestingly enough, it is not a paper at all. Rather it is 100 percent polypropylene. Because it's nonabsorbent, you can achieve amazing watercolor-like effects with ink and acrylics. Erase paint and create layer upon layer of glazes and amazing marks with this unique product. On these pages, I'll introduce some basics for creating backgrounds with Yupo paper, and we'll return to this surface in a future chapter.

Materials list

Black India ink

Brayer

Brush

Golden high flow acrylics

Golden fluid acrylics

Neocolor II crayons

Paper towels or baby wipes

Rubbing alcohol in a spray bottle

Scraping tools

Stencils

Water-soluble pencils

Yupo paper

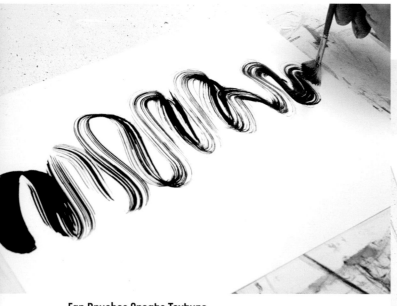

Fan Brushes Create Texture
Use a fan brush to apply the India ink to the Yupo paper.

Rubbing Alcohol Spreads the Ink
Brush black India ink onto the surface. While wet, add a spritz of rubbing alcohol.

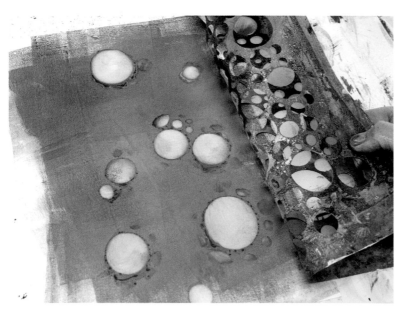

Use Stencils
Use a brayer to apply black India ink until the ink is thinned out and dry. Apply a stencil to the surface. With a soft slightly damp paper towel or cloth, rub areas of ink away from the stencil openings to reveal patterns.

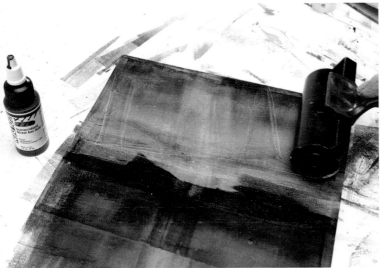
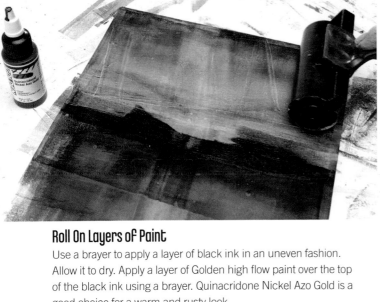

Roll On Layers of Paint

Use a brayer to apply a layer of black ink in an uneven fashion. Allow it to dry. Apply a layer of Golden high flow paint over the top of the black ink using a brayer. Quinacridone Nickel Azo Gold is a good choice for a warm and rusty look.

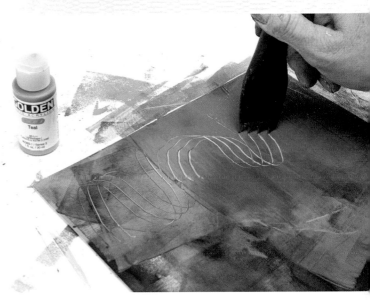

Go Lightly With Fluid Acrylics

Use a very light layer of fluid acrylics on Yupo paper. Adding too much at one time can cause the paint to crack off the surface once it's dry.

Use Fluid Acrylics

In addition to Golden high flow acrylic, you can also apply fluid acrylic for an opaque look. Use a cataylst blade to scrape into the wet paint for additional texture.

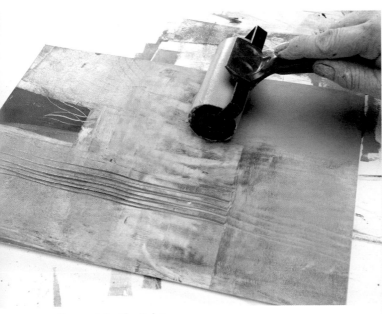

Scrape Into the Paint

Use the side of your brayer to scrape the wet paint. This technique removes paint layers and creates unique marks. Alternate directions to build depth.

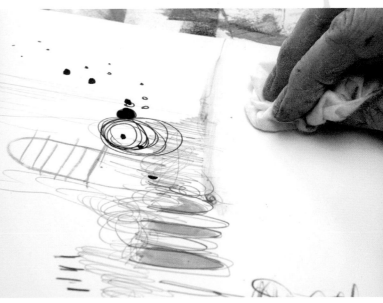

Wipe Away Paint and Blend

In addition to paint, you can also use pencils, markers and crayons on Yupo paper. Rub away areas you do not want with a baby wipe, or swipe gently for a cool blending effect. Be adventurous!

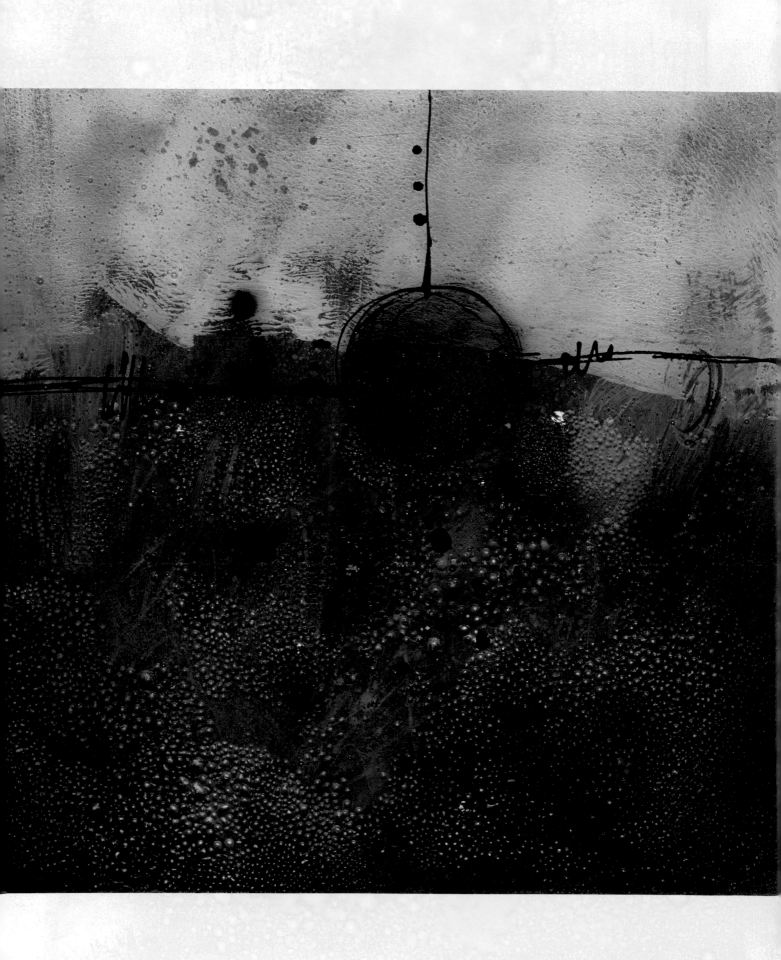

Textured Tiles

THIS IS A GREAT PROJECT FOR LETTING LOOSE AND EXPERIMENTING without the pressure of creating a complex design. The idea is to build up layers of glazes to create an intense color while manipulating the surface with heat. You will need to use Claybord and a heat gun to get the effect of the raised bubbles. The texture will not be possible if you use wood or canvas. I love how the effects are unpredictable when you add heat. You can add as much or as little texture as you like—with a little practice. The Silks acrylics are somewhat water-soluble and will bleed through the top coat of gel mediums, so it's best not to worry about the details. Rather focus on color, texture and subtle patterns.

Materials list

Ampersand Claybord

Assorted Silks acrylic glazes

Brushes

Carbon Black fluid paint

Ceramic tile

Dust mask

Fineline applicator

Glazing medium

Golden tar gel

High-powered heat gun

Large palette knife

Paper towels

Primary Elements pigment powder in Iridescent Green

Rubbing alcohol

Soft brayer

Spray bottle

Spray varnish

Titanium White acrylic paint

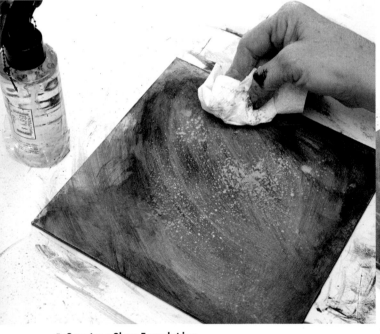

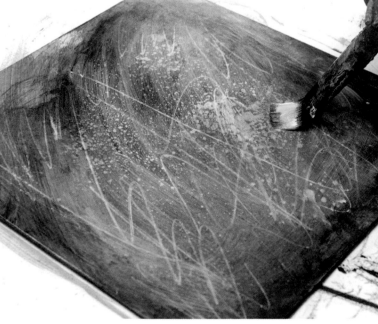

1 Create a Glaze Foundation
Make a small mixture of glaze using Carbon Black Fluid acrylics and glazing medium. Brush on the paint lightly and immediately rub off to create a stain. Scratch into the surface using the back of your paintbrush. Remove some paint by spritzing water and picking up the color with a paper towel.

2 Add Another Glaze
Create another glaze using a mixture of the Primary Elements pigment powder and glazing medium. Brush it on random areas. Keep any leftover glaze mixture so you can use it throughout the painting.

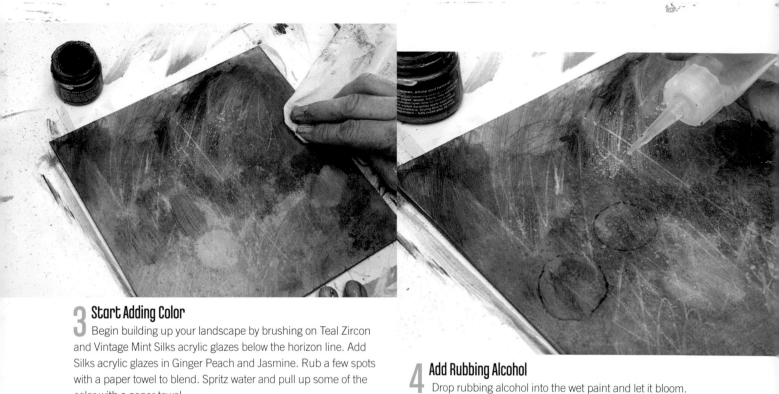

3 Start Adding Color

Begin building up your landscape by brushing on Teal Zircon and Vintage Mint Silks acrylic glazes below the horizon line. Add Silks acrylic glazes in Ginger Peach and Jasmine. Rub a few spots with a paper towel to blend. Spritz water and pull up some of the color with a paper towel.

Because Silks acrylics are glazes, you need to apply multiple light layers to build up depth. They are water-soluble even though they are acrylics.

4 Add Rubbing Alcohol

Drop rubbing alcohol into the wet paint and let it bloom.

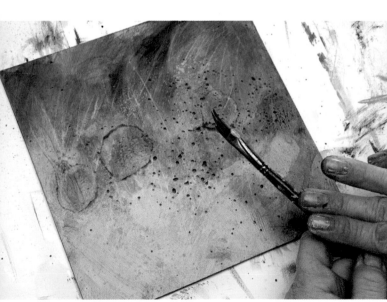

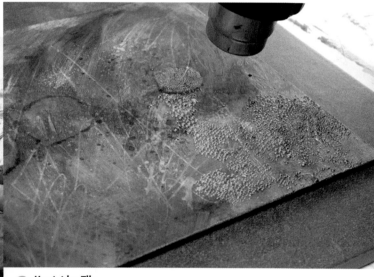

5 Add Paint Splatters

Pick a contrasting color and load the brush with it. Tap the brush over the piece to add paint splatters.

6 Heat the Tile

Add heat to alter the surface. Protect your worktable by placing a ceramic tile under your substrate. While the paint is still tacky, use a high-powered heat gun on the highest setting to heat the tile. Little bumps will form on the surface. I recommend wearing a face mask during this step to avoid inhaling fumes. Make sure you work in a well-ventilated area. The tile will be extremely hot, so handle it with care.

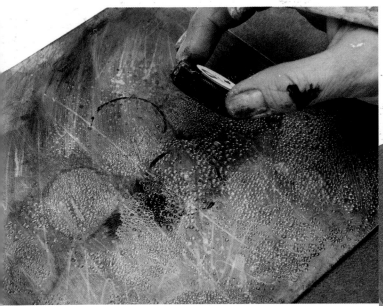

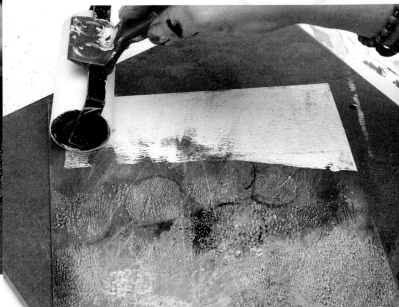

7 Stamp Circles

Continue adding the glazes to build up color. Be cautious around the bubbles as they can easily break if you brush on the paint too harshly. Add circles and other patterns to your design along the horizon line.

8 Roll on White

Add a layer of Titanium White acrylic with a soft brayer. The glazes will bleed up slightly into the white acrylic paint but that just adds to the overall look.

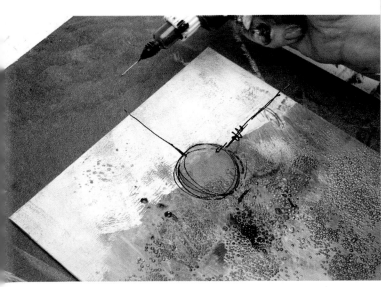

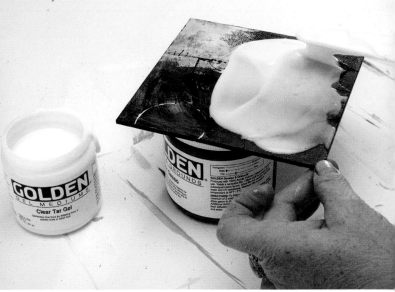

9 Add Details

Use a Fineline applicator to add details and marks. Add a few paint splatters of Silks acrylic glaze in Jasmine. Allow the piece to dry 24–48 hours depending on your climate before finishing. Once fully dry, apply a topcoat of spray varnish in matte or glossy.

10 Seal the Piece

After the spray varnish is fully dry, add Golden's tar gel medium for a glossy, almost underwater look. Apply the medium over the entire surface with a large spatula or palette knife. Take care not to move quickly or in too many directions, as you may create air bubbles.

Check the piece several times over the first few hours for air bubbles that may occur. Pop them with a toothpick if they do appear early on in the drying process. It will dry to the touch in a day or two; however, it may take several weeks to fully cure.

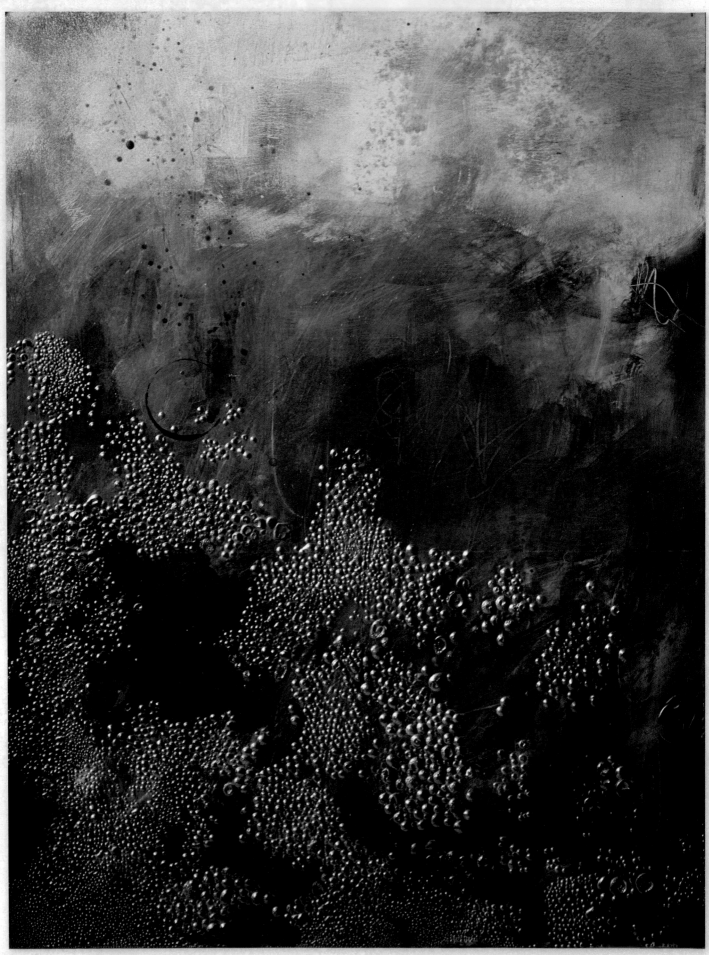

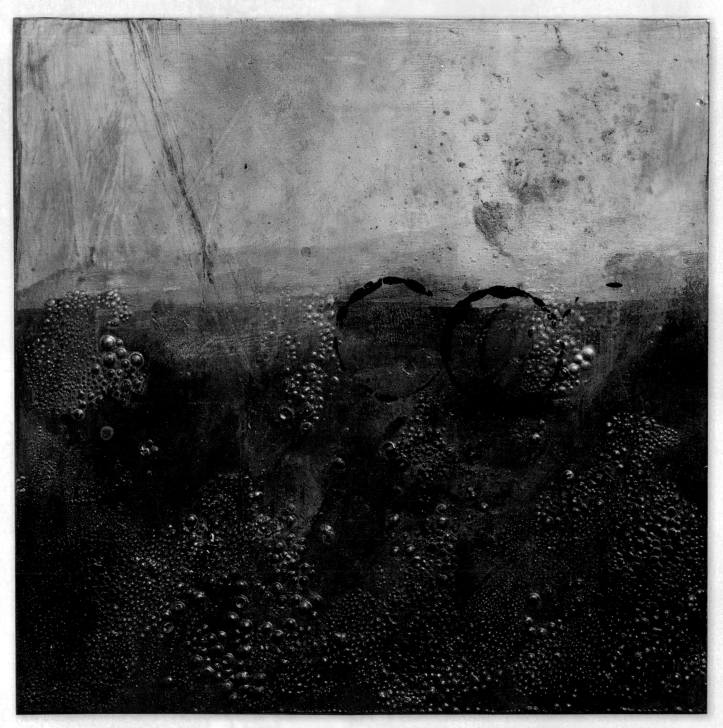

▲ **LEAVING THE ISLAND**
8" × 8" (20cm × 20cm), mixed media on
Claybord

◄ **MEADOW LANDS**
12" × 16" (30cm × 41cm), mixed media on
Claybord

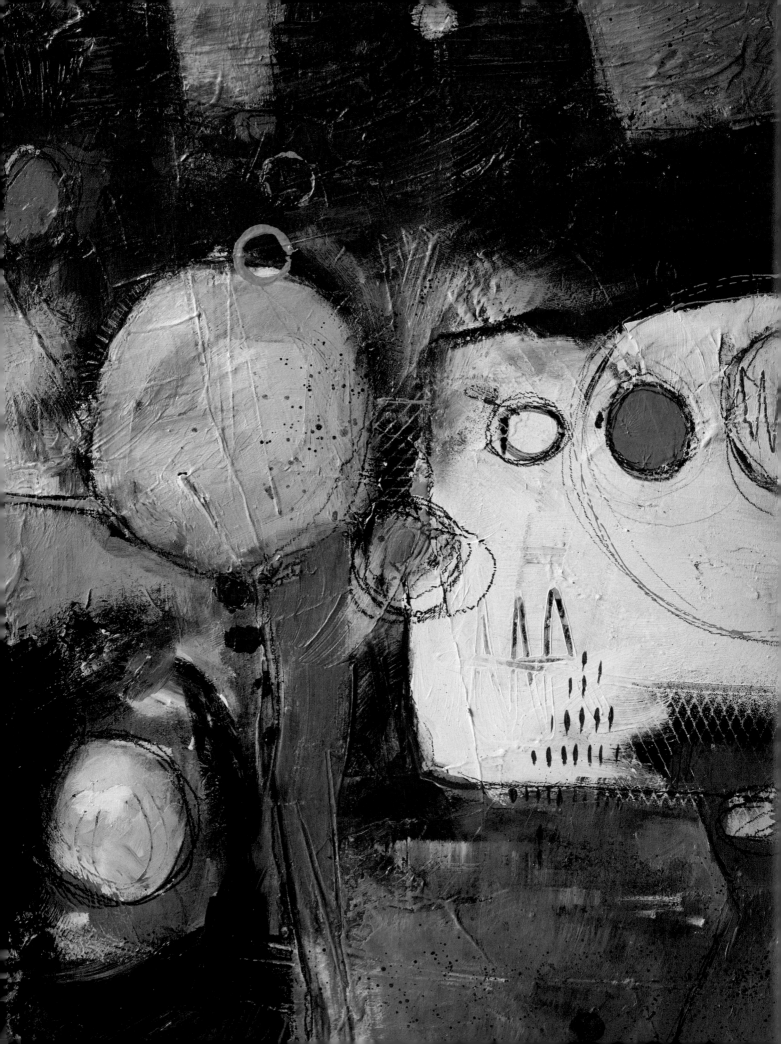

2 Experimenting With Mediums

◀ **THE PLACES IN BETWEEN**
12" × 16" (30cm × 41cm),
acrylic and drawing mediums
on wood

GEL MEDIUMS aren't just for gluing paper down for collage!
We will be using a variety of gel mediums throughout this
book to create interesting textures, cracked surfaces, glazes,
veils, stains and, of course, to adhere papers to a surface.
Understanding when and where to use a particular medium
has made every artist's mind reel at one time or another. It's
confusing because many of the mediums seem like the same
product. For the most comprehensive resource on how to
use mediums, I recommend consulting and bookmarking
the manufacturer's website. You can also jump in and do a
few fun experiments to help you understand what each of
the mediums offers. Over the next few pages, I've showcased
a few that will be used in many of the upcoming projects.
You don't need to use every medium in each project, but
my guess is that you'll find a few that you won't be able to
live without once you start experimenting. Creating your own
unique marks on your abstract paintings will help distinguish
your art from the rest of the crowd.

About Change or Expansion
"The only way to make sense out of change is to
plunge into it, move with it and join the dance."
— ALAN WATTS

Using Various Mediums

HERE'S A QUICK SAMPLER of some of my favorite textural mediums to incorporate into acrylic paintings. Don't be afraid to try something new. You'll find that the possibilities are endless with these versatile supplies.

Modeling Paste

Apply modeling paste with a palette knife to achieve a variety of plaster-like textures. It dries to an opaque finish. Light modeling paste is best over paper or canvas. Heavy modeling paste is best on wood or a hard surface.

Fiber Paste

Fiber paste dries opaque with a rough, paper-like texture.

Glass Beads

Glass beads dry clear on a surface. Once dried, you can still see the under layers.

Tinted Fiber Paste

Try tinting any of your pastes with a few drops of acrylic paint to change the look of your textured layer.

Use Many Different Textures

Experiment and use more than one textural medium in your work to achieve a variety of interesting looks. Consider using stencils with your mediums to create a pattern.

Demonstration

Using Crackle Paint

CRACKLE MEDIUM IS PERHAPS ONE OF MY FAVORITE MEDIUMS to use to simulate an aged and weathered look. You can find crackle medium as a clear gel, tintable paint or opaque paste. Each will generate a slightly different look, but typically the thicker the application the larger the cracks, and the thinner the application, the more delicate the fissures will appear. Patience is needed when applying crackle medium. Sometimes up to 24 hours is needed before the medium is cured enough to paint over.

Materials list

Assorted fluid acrylics

DecoArt Media crackle paint

Gold metallic paint

Matte medium

Paper towels

Painted surface

Spray varnish

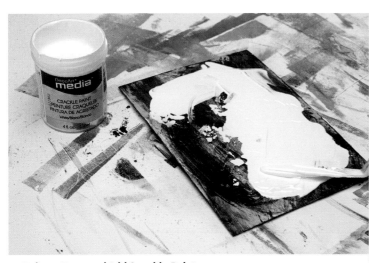

1 Paint a Base and Add Crackle Paint
Paint a surface with two to three layers of paint and allow to dry. Next, apply a layer of crackle paint. Let dry. The thicker your application, the more distinct the cracks will be.

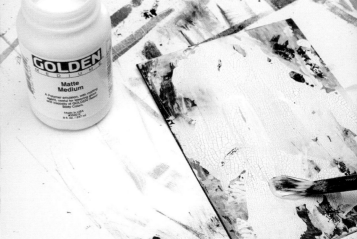

2 Protect the Crackle Paint
Once the crackle layer is dry, apply a layer of matte medium to protect the crackle surface. Let dry.

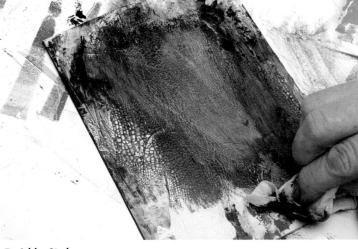

3 Add a Stain
Stain the crackle layer with black paint. Spray water over the surface to thin out the paint. Wipe away.

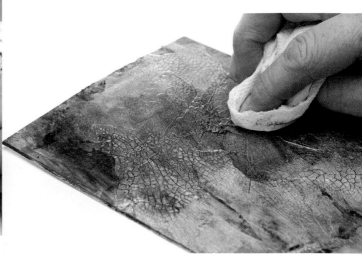

4 Add Color
Develop the piece with additional paint layers. Rub a touch of gold metallic paint to add to the depth. After your piece is dry, protect the surface with a layer of spray varnish.

Leveling Mediums

UP UNTIL NOW, I've been talking a lot about using textural mediums to alter your surface. Leveling gels are a bit different in that they are clear and you can use them to drip paint into, to mix with paint, or to cover a piece as a glossy topcoat. Take a look at some of the examples showcasing the versatility these gels offer to give your paintings some extra pizzaz.

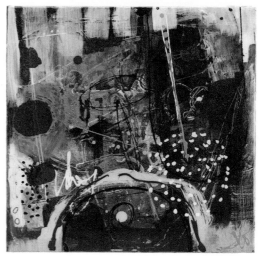

Tar Gel

Tar gel is a thick honey-like leveling gel that can be mixed with paint to create stringy lines when dripped from a distance onto the surface. You can also use it as a top-coat to mimic resin. When adding paint in drops you get a more controlled bloom. Try adding paint in drops onto a surface that has a top coat of tar gel that is still wet. The result will look like paint that is floating above the original surface. If you use tar gel, you'll have to work with an extended period of curing time due to its thickness. Avoid wrapping your finished piece in bubble wrap or anything that could potentially leave marks in the surface.

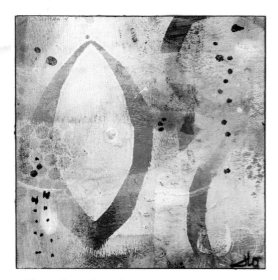

Self-Leveling Gel Medium

Self-leveling gel medium is the thinnest gel in the leveling family. I used it to add subtle dimension to the thin layers of paint used in a printmaking fashion using stencils and masks.

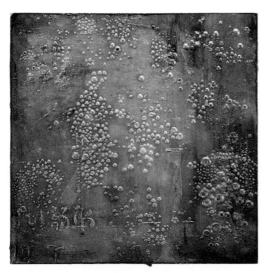

Using Self-Leveling Gel Medium For Protection

Self-leveling gel medium provides protection to the surface bumps here without adding the thickness of tar gel. The viewer can see and feel the texture. The gloss coating enhances the rich glazes underneath, enriching the overall color intensity.

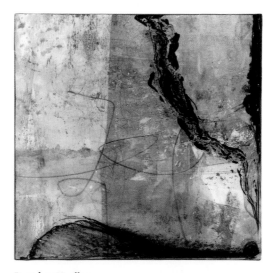

Pouring Medium

Pouring medium is a leveling gel that falls between tar gel and self-leveling gel in viscosity. Once the topcoat is dry it's not as thick as tar gel. Dropping paint into a wet topcoat of pouring medium will react differently than the tar gel. Notice how the black line glides and blooms more freely when added to the medium. The paint dropped in here resulted in a more organic shape.

Demonstration

Creating an Acrylic Skin

I THINK MOST ACRYLIC PAINTERS are familiar with the acrylic skins that appear on your palette when the liquid part of the paint has dried, but did you know you can also create a more hearty skin to use as a colorful collage element? When drops of paint meld together in the gel medium, the result can be a beautiful marbled pattern that would be hard to re-create any other way.

Materials list

3-4 Golden fluid acrylics colors

Dura-Lar wet media film or an acetate sheet/page protector

Liquitex pouring medium

Palette knife

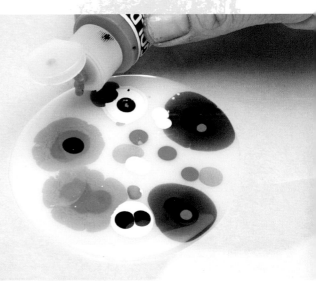

2 Drop In Color

Immediately drop several colors of fluid acrylic paint into the medium.

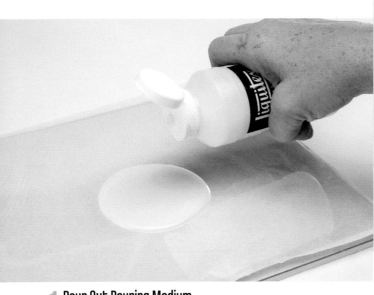

1 Pour Out Pouring Medium

Pour a dollop of pouring medium onto your nonstick surface.

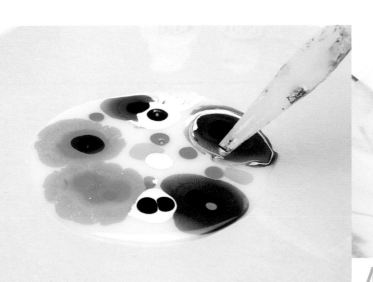

3 Mix the Colors

Using a palette knife or a skewer, mix the colors around.

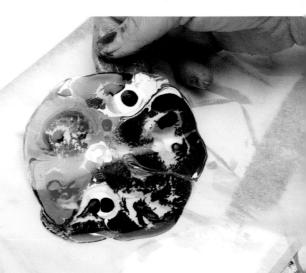

4 Let Dry and Lift the Skin

Allow it to dry for at least a day. Carefully pull the skin from your surface. You may find the underside is even more interesting than the top. The skin can be cut or used as is in as a collage element in your artwork. Store any unused portion of the skin between two nonstick surfaces, such as acetate sheets or page protectors.

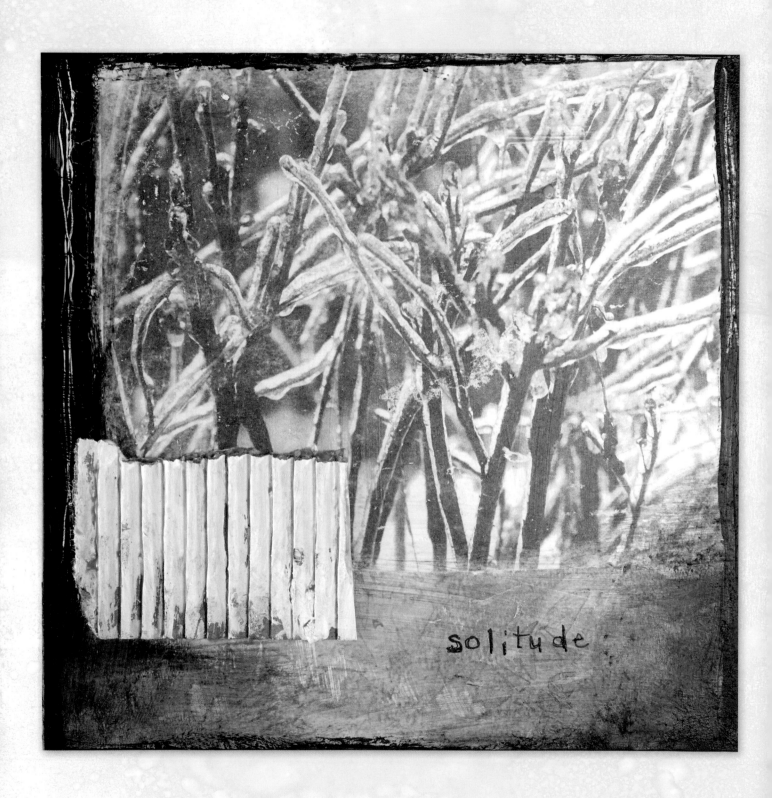

Demonstration

Gel Medium and Gesso Transfer

FOR AS LONG AS I CAN REMEMBER, I've been enthralled with the process of creating an image transfer. The look achieved when using a transfer in your work has an ethereal quality, often hazy and imperfect. The weathered look is hard to replicate by adhering a photo to a collage or painting. While there are many different image transfer techniques you might use, I'm sharing the gesso transfer technique as it is a fairly simple process using supplies you probably already have on hand.

Materials list

Ampersand Claybord

Black-and-white laser copy image

Brayer

Brush

Deli paper

Extra embellishment (painted corrugated cardboard)

Gesso

Golden's polymer medium

Ink pen or calligraphy dip pen

Matte medium, soft gel medium

Payne's Gray, Carbon Black and Titanium White acrylic paints

Soft cloth

Sponge

Spray bottle with water

1 Paint a Gesso Base
Cover the Claybord with an even layer of gesso. You will want a layer with a medium level of thickness. You don't want it to be super heavy because it won't dry evenly, but if it's too thin your image won't transfer the ink into the medium.

2 Press the Printed Image Into the Gesso
Decide where you want your laser copy image to be placed. Lay the paper image side down into the wet gesso. Gently press the image down.

41

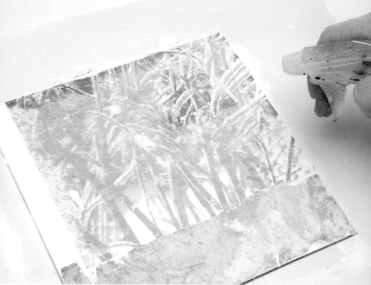

3 Burnish the Image
Place a sheet of deli paper over the top of your image. Burnish to ensure good adhesion to the surface and to eliminate any bubbles. Let dry (up to a day).

4 Get the Transfer Damp
Once dry, gently lift the first layer of paper by pulling and lifting the back. Spray the back of the paper with some water until you can see the image more clearly. You want the back to be damp but not sopping wet.

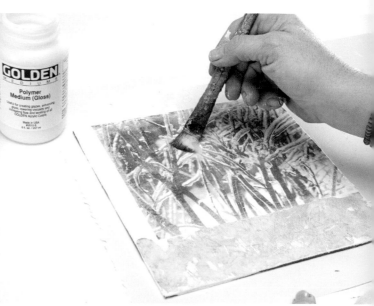

5 Peel Away the Paper
Roll the paper fibers away throughout the piece by dragging your fingers across the wet paper. Try not to use too firm of a touch or you may rub more than just the back paper fibers away. It's normal for this process to take a while to complete. Ideally, peel back as much paper as you can initially, let the image dry and then repeat the next day. Often there's residual paper left behind that you don't immediately notice during the first pass through.

You can use a soft sponge to remove excess paper fibers too. Remember to be gentle with the pressure. Too much force will remove the image itself. The result will be an interesting, weathered look, not a perfect transfer.

6 Seal the Transfer
Once you've peeled away all of the paper, apply polymer medium to the transfer to seal and protect the surface. This sometimes will also lessen the appearance of any leftover paper fibers.

7 Paint on Details
Begin finalizing your details by painting on simple touches (such as the black frame in this example). Add more texture by scraping into the wet paint with the back of your brush.

8 Paint a Veil
Tie the composition together by mixing a veil of color using matte medium with a small drop of Payne's Gray (or another neutral color, depending on the overall mood of your artwork). Apply with a brush over the entire piece.

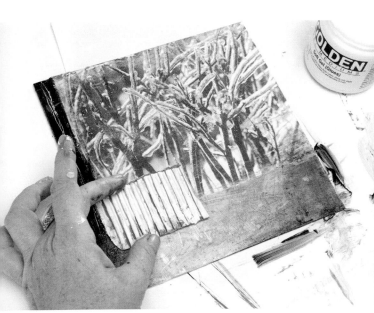

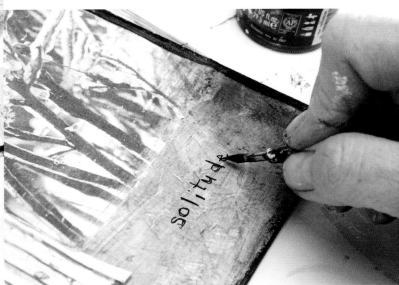

9 Add Collaged Elements
Add any 3-D embellishment you like. Paint a piece of corrugated cardboard with a dry brushing of Titanium White. Use soft gel medium to adhere it.

10 Final Details
Finish framing out the artwork with black paint. Rub the edges with a soft cloth to blend. Add a word or title that conveys your mood with a pen.

Keep Copies of Art
The bottom portion of this image transfer was a laser copy of a collage paper made in a previous printmaking session. Save your favorite papers by making copies before using the original papers in your art.

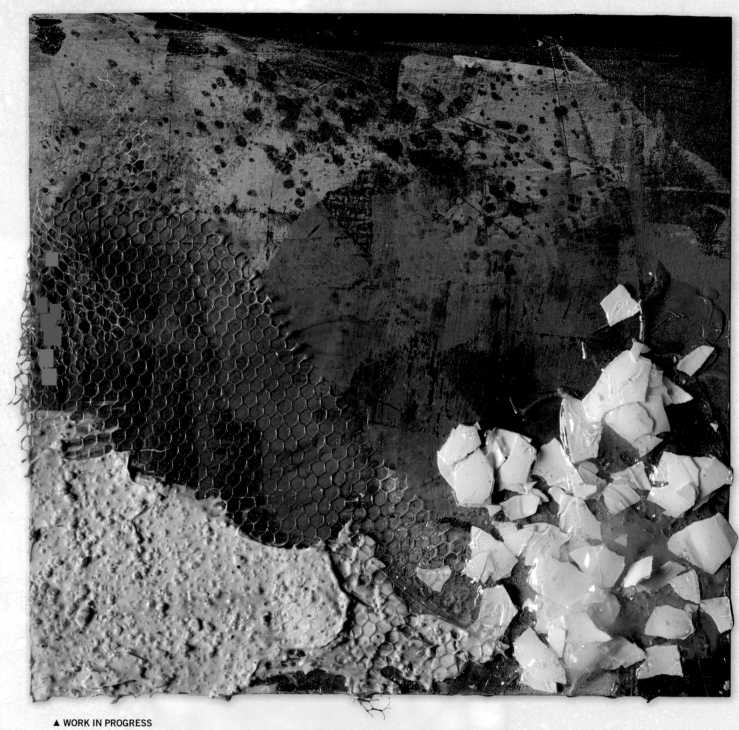

▲ **WORK IN PROGRESS**
6" × 6" (15cm × 15cm) mixed
media paint and collage

Noncommercial Add-Ins

IS YOUR MIND WHIRLING WITH IDEAS for how you can use gel mediums in your abstract paintings? As you have probably noticed, the possibilities are endless for achieving unique marks and textures in your compositions. Don't stop with the commercial products, look around your house and see what else you can use in your work that may provide for great substitutions or additions to your mediums. I bet you'll find a lot of possibilities for add-ins if you really look. The sample showcased is a work in progress, showcasing just a few of the noncommercial add-ins I had on hand.

Materials list

Add-ins: Things you find around the house or out in nature—sand, cleaned eggshells, fabric, netting, twigs, wire, glass

Assorted acrylic paints

Molding paste

Palette knife

Soft gel medium

Wood or other hard surface

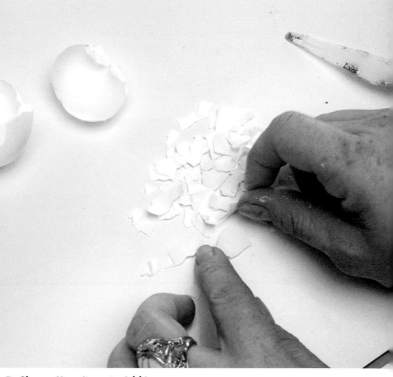

1 Prepare a Background
Prepare a painted surface. (You may want to explore one of the techniques in the featured demonstrations). Let the background dry.

2 Choose Your Item to Add In
Gather the items you want to add to the gel mediums to achieve experimental surface texture. Here I'm using egg shells to mimic a homemade crackle effect. Crush cleaned shells into small pieces.

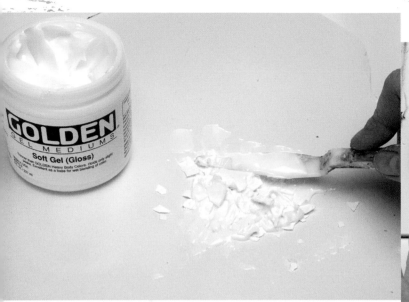

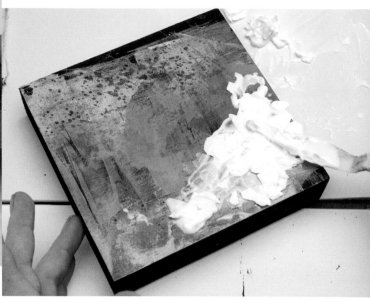

3 Mix the Shells and Gel
Gently mix the shells into a soft body gel medium to make a clear paste.

4 Spread the Mix on the Piece
Apply the eggshells to your substrate with a palette knife. Let dry.

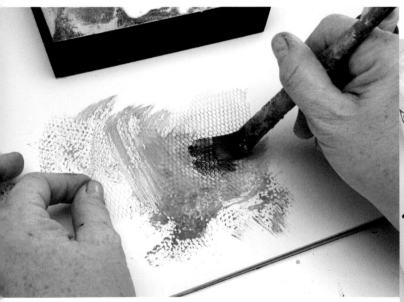

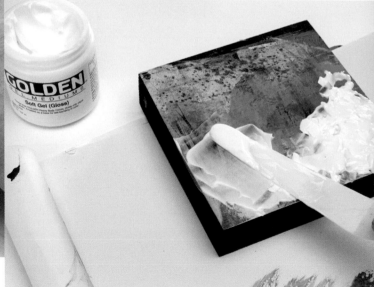

5 Paint Netting
Paint a small piece of netting or mesh fabric to coordinate with your background.

6 Add Gel Medium
Add soft gel medium to the area you want to place the netting (or the next add-in you choose).

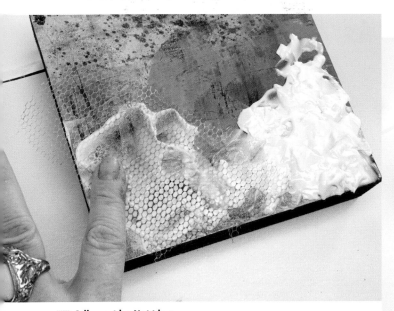

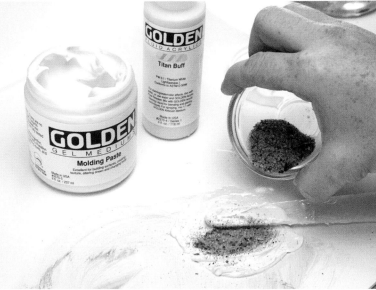

7 Adhere the Netting

Press the painted netting into the gel medium. Once dried, the medium will be clear.

8 Create a Textured Mixture

Mix a small amount of Titan Buff into molding paste. Add some sand from your last trip to the beach. Mix it all together.

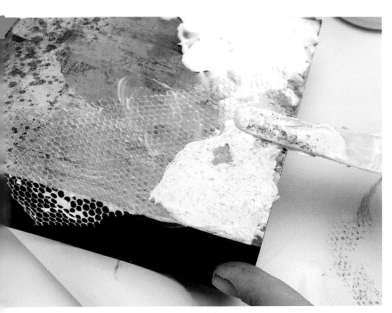

9 Apply the Textured Mixture

Apply the modeling paste/sand mixture to your surface. Allow all mixtures to dry before embellishing with paint.

Jump Start Your Creativity

Let the ideas in this chapter be a jumping off point for you as you seek interesting items to add to your paintings. What else can you find to mix with gel mediums to make unique textural effects?

How to Create Stains, Glazes and Veils

WITH SO MANY DIFFERENT TYPES OF GEL MEDIUMS to choose from, it's easy to get confused when selecting one for your project. Creating veils, stains and glazes are other ways to use mediums in addition to the processes we've already discussed. These techniques are used to enhance color, to create layers of translucency or to pull back and, well, *veil* color. Take a look at some of the samples so you can visualize each method before putting them to use in larger works.

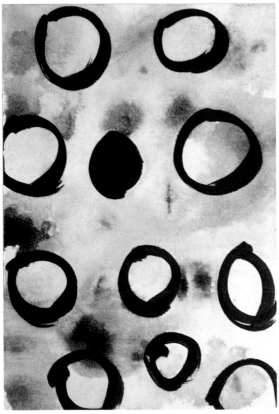

Create a Wash
Add water to your surface and drop paint into the pools. Allow to dry for a watercolor look.

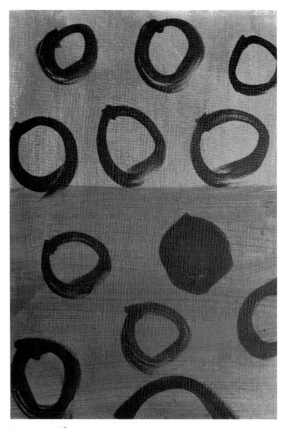

Create a Glaze
Add glazing medium to your paint for a translucent hue. Reapply a layer of glaze to deepen the colored effect while not covering the bottom layer entirely.

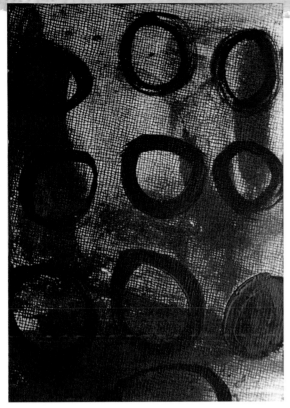

Create a Stain

Brush a light coat of paint onto the surface. Rub the pigment into the surface with a soft cloth. In effect, you will stain the surface with color.

Translucent Colors

Notice in this example how the black line appears through the dried paint. Translucent colors of paint allow light to pass through them more readily than opaque colors. In essence, you can see through the paint. When choosing paint, many brands will either label their paint translucent or apply a swatch of paint to the tube/bottle with black lines to so you can see how a color looks when dried.

Opaque Colors

Opaque colors do not allow light, or only very little, to pass through the dried paint. The result is a solid layer of color. When you add opaque colors of paint over another color, you will mask what is underneath.

Understanding Opacity

Understanding the opacity of a paint is important for an artist because the choices you make when you comprise your palette will affect how you are able to layer, blend, glaze, veil, stain and create luminous or richly dense paintings. I recommend making color charts of paints you own by brand using this method of drawing a black line for your reference. This is especially helpful if you are a beginning painter or purchasing a line of paint from a manufacturer you have not used yet.

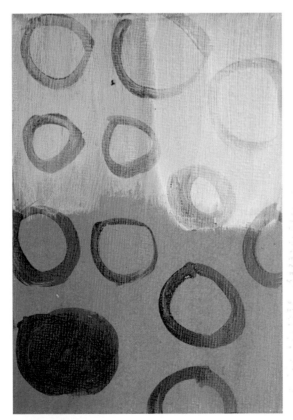

Create a Veil

Paint the surface. Mix matte medium into your topcoat to dilute the color. The result is a soft, frosted hue when dry.

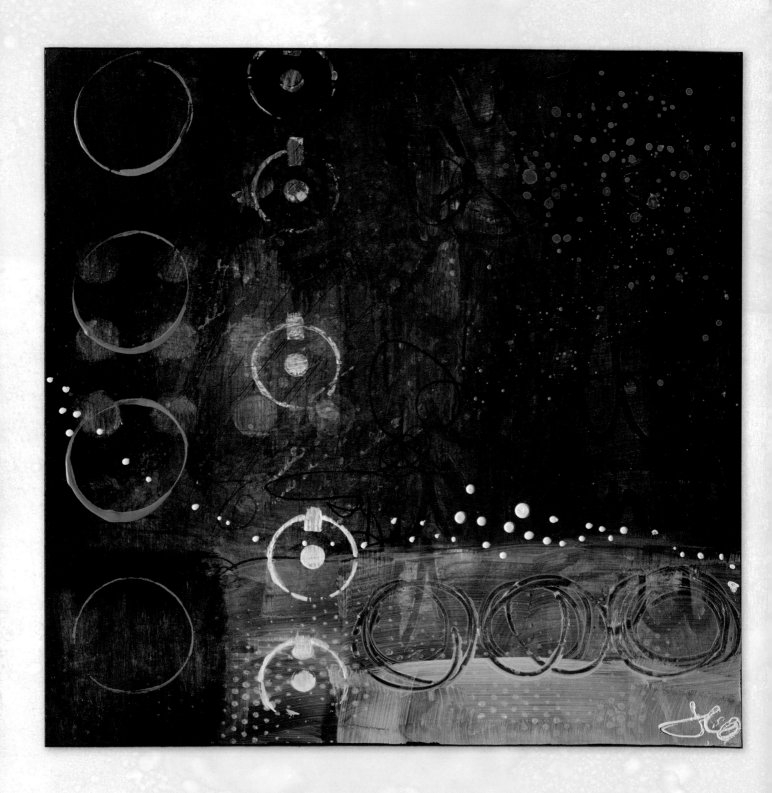

Creating Depth With Glazes

ONE OF THE MORE USEFUL MEDIUMS for an acrylic painter is glazing medium. It basically is the basis of fluid acrylic paint without the pigment. Traditionally glazing medium is used to create translucent layers of color. It can also be used to help your acrylics last longer than they normally would or as a binder for dry pigment so that you can make your own paint. In this demonstration, we will focus on creating depth through multiple layers of paint and glazes. The key to creating rich color in many cases is many light layers of paint. Mixing your paint with a touch of glazing medium keeps the paint bright and intact so that the beautiful color shines through. If you add too much water to a paint, it becomes dull and breaks down the binder, making it unstable. The result of too much water mixed with paint is potential cracking or peeling of the color on a surface.

Materials list

Ampersand Claybord tile

Assorted fluid acrylic paints: Carbon Black, Indian Yellow, Quinacridone/Nickel Azo Gold, Teal, Titan Buff, Titanium White

Brushes

Fineline applicator

Golden high flow acrylic in Sepia

Jerry's Jumbo Jet Black pencil

Matte medium

Paper towel

Spray bottle with water

Stencils

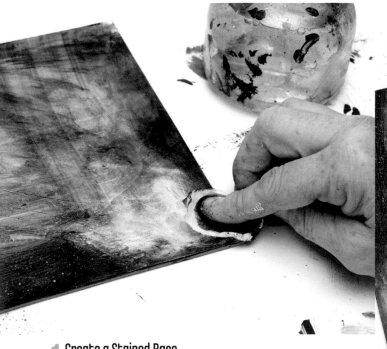

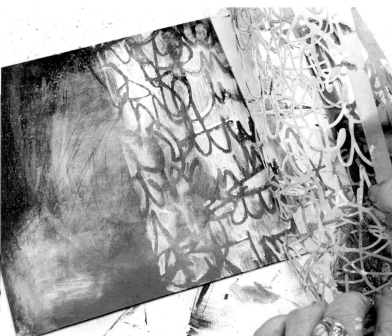

1 Create a Stained Base

Stain the Claybord surface with black acrylic paint. Add water to the surface and wipe away random areas of paint to create a blackboard effect. Scratch the surface as you are wiping away paint with your fingers. Use a baby wipe if you find it hard to remove the paint.

2 Stencil Paint On

Add a stencil design with Titanium White acrylic. The key to getting a good impression with a stencil is to use a dry brush and a minimal amount of paint. You can also use a cosmetic sponge. Once the white paint is dried, it will recede into the background after glazing over the top with additional paint layers.

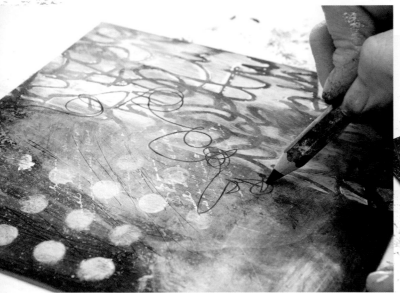

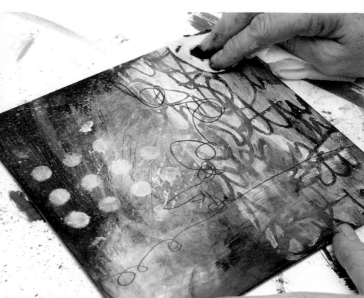

3 Add Scribbles With a Pencil
Continue adding one or two more stencil designs if desired. Then scribble and write over the surface with a Jerry's Jumbo Jet Black pencil. The pencil writes best if the paint is somewhat dry.

4 Add a Stain
Once the stencil layer is dry, stain a section with Golden's high flow in Sepia. Notice how the white design fades into the background.

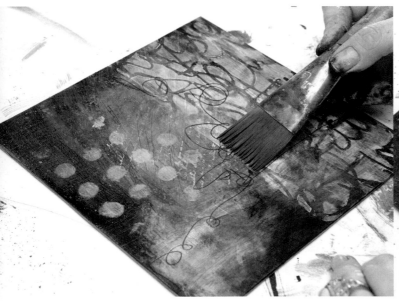

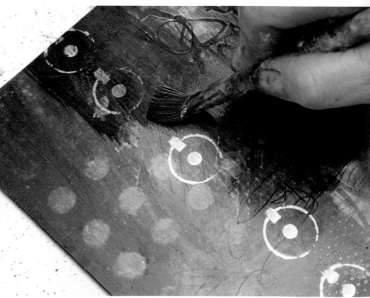

5 Add a Glaze
Add a glaze of color using Indian Yellow around the tile. Gently stroke on the paint using a large brush. The color is translucent so you will create a glaze over the top of the surface.

Using glazing medium on the initial layer of Claybord will actually remove the subsequent layers. It's important to know your surface and how it reacts with different products to achieve the effect you desire.

6 Build Up the Layers
Repeat layers of stamps or stenciling. Add thin layers of color, bringing in Quinacridone/Nickel Azo Gold. Notice how the colors create depth as you add more layers.

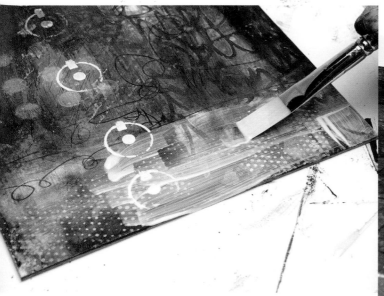

7 Add a Veil

Create a veil of paint over a portion of your surface. To do so, mix a small amount of Titan Buff with fluid matte medium. As described in previous experiments, the resulting effect is similar to frosted glass in that the paint will be semiopaque once dry.

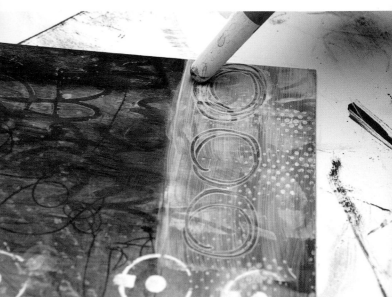

8 Scratch Into the Paint

Add sgraffito-style designs by inscribing into the tacky paint with the back of your brush. Pulling back the paint at this point reveals the underlayers, which add to the overall sense of depth.

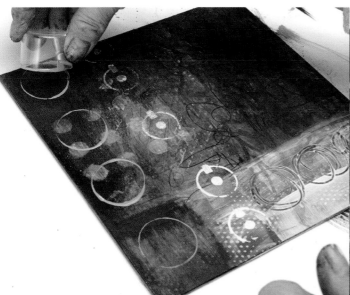

9 Add a Pop of Color

Bring in a contrasting color (Teal) through stamping and splattering. These elements will create interest and complement your existing design.

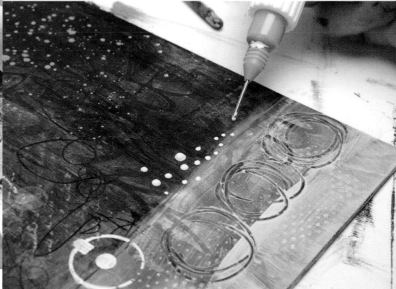

10 Final Details

Add final markings using a Fineline applicator filled with Titanium White fluid acrylic.

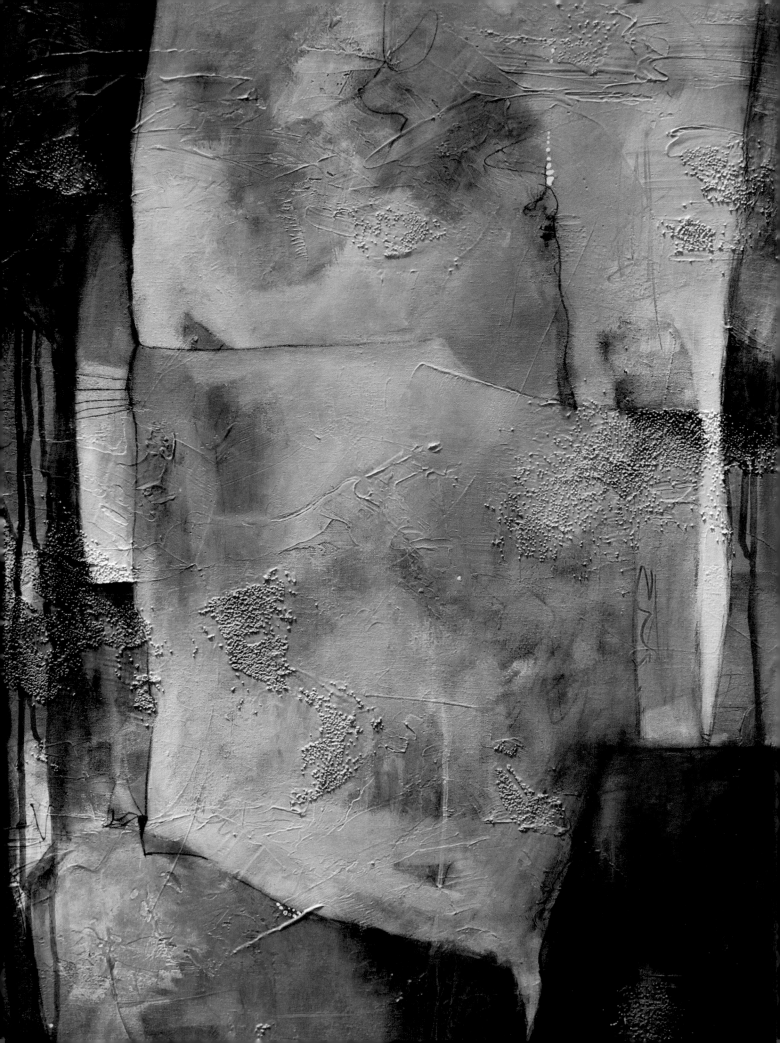

3 Understanding and Applying Art and Design

AROUND TEN YEARS AGO, when I first started dabbling in art, I just plunged in headfirst with no regard to what was supposed to go where, how or when. It was a similar approach to the way a child takes to most things in life, with a natural curiosity unencumbered by authoritative rules. I feel like I still dive into my art with that same instinct and fearless approach, however, as I grow, I am starting to recognize what makes one painting of mine more successful than another. When I'm stuck and something is not working, I look to the elements of art and principles of design for guidance.

While we aren't going to study what each of these sets of guideposts means in depth, I want to at least share a basic definition with you so that you can refer back to them when you are in need of direction. When looking up these fundamental elements and principles for the book, I noticed that depending on where you look, they vary. Many times elements and principles overlap with one another depending on which resource you consult.

About the Unknown

"Uncertainty is a very good thing: it's the beginning of an investigation, and the investigation should never end."

— TIM CROUCH

Elements of Art and Principles of Design

Elements of Art

Color exists when light is reflected off an object. With the absence of light you have black. You can break down color to three primary categories that describe its characteristics: Hue (or the color name), Value (how light or dark a color is) and Intensity (or saturation of a color).

Form refers to three-dimensional objects. In two-dimensional work, the perception of form can be achieved with shading and highlighting.

Line is recognized as the marks or dots between two spaces. A line can be straight, curvy, thick or thin.

Shapes are closed lines that create geometric or organic designs, such as a circle or square. Organic shapes are ones that appear in nature or by accident from marks that are made on a surface.

Space is often referred to as positive (the area inside an object) or negative (the area around an object).

Texture is the tactile surface that can be felt or seen in a work. An artist can create the illusion of texture using paint, drawing tools or instruments.

Principles of Design

Balance is the visual distribution of weight in a composition. It may be symmetrical, where all portions are equal in the distribution, or it may be asymmetrical, where the areas are different but appear to be balanced.

Contrast is the close positioning of objects or elements that are opposites in nature to create emphasis, such as light and dark, thick and thin, busy and calm.

Emphasis is the part of your design that is the focal point, the place that is intended to capture the viewer's attention.

Pattern is the placement of objects or marks repeated throughout a work, or a repetition of a mark, object or symbol.

Rhythm or Movement is the path a viewer takes through a work due to the placement of objects or shapes by an artist. Normally movement will lead a viewer to the focal points of a work.

Unity and Harmony are the cohesiveness of the piece or the emotion that results when you consider the arrangement of elements as a whole.

Size is the proportion of elements and how they relate to one another.

Variety is the use of several elements to create an engaging experience that holds the viewer's attention.

Analyzing a Piece, *We Go Round and Round*

1. *Unity* and *harmony* are created by the arrangement of circles shapes repeating throughout the piece and by the use of limited colors within the composition.

2. *Movement* is further developed through the gestural and sometimes heavy handed lines drawn from the edge of the piece, around the shapes and scribbled in areas.

3. *Texture* added through gel mediums and multiple layers of paint adds to the weight and depth of this composition creating a sense of history with a bit of tension.

4. The red circles in the green circle shape, suggest *emphasis* to that area of the painting. The use of opposite colors on the color wheel (green and red) further direct the viewer to that shape as it visually *contrasts* with one another. The viewer can choose to decide what that particular focal point means when their eye is guided in that direction by the artist.

tip: As an artist, carefully consider how to pull the elements and principles together to make a painting more impactful. In the end, only you can decide what to include and what to leave out, which area to emphasize, and what path you hope the viewer takes as they visually move throughout your work.

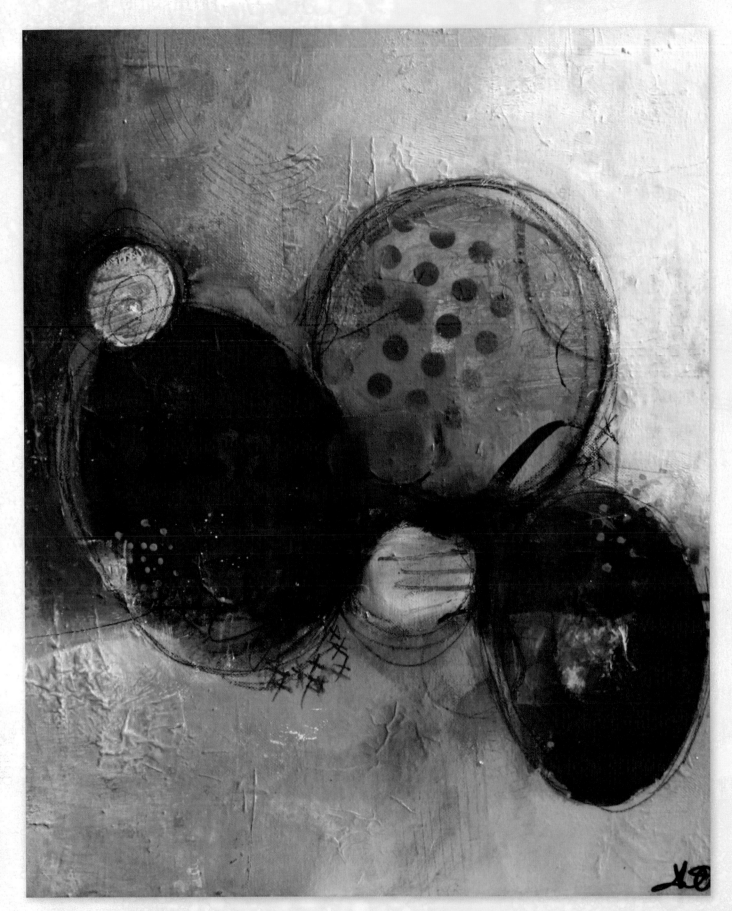

▲ **WE GO ROUND AND ROUND**
16" × 20" (41cm × 51cm), mixed media acrylic,
collage and drawing media on canvas

Creating Your Own Colors

IF YOU HAVE ONLY A FEW ACRYLIC PAINT COLORS in your artist toolbox, have no fear! It's not hard to create your custom color mixes. With just a few different colors and black and white, you will be on your way to an expansive color palette in no time.

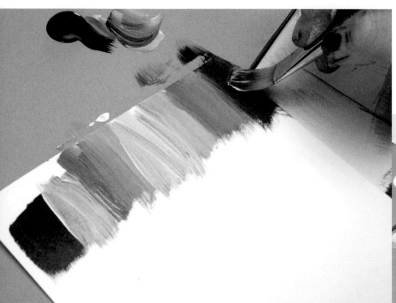

Create a Gray Scale
Start by making a gray scale for each of your colors. Begin with your base hue and add white to continually lighten it. Continue mixing different shades and tints by incorporating black as well.

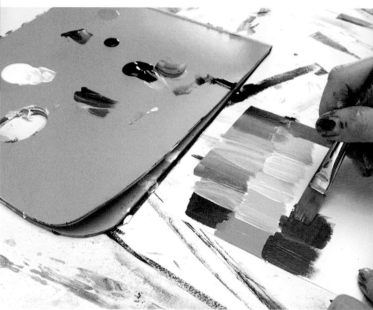

Use a Gray Palette to Help Colors Pop
Try using a gray paper palette to truly see the colors in their best light.

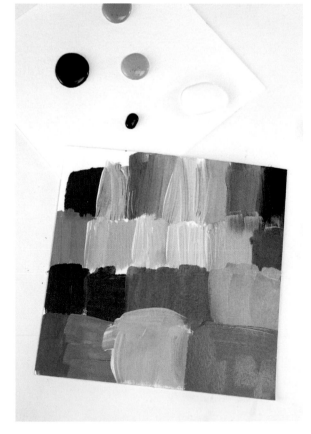

Keep Mixing and Creating Colors
After you mix your gray scale of colors, try mixing the paints with one another to create custom colors. Add black and/or white to change the values once again. Take time to explore the possibilities you have even with a limited color palette.

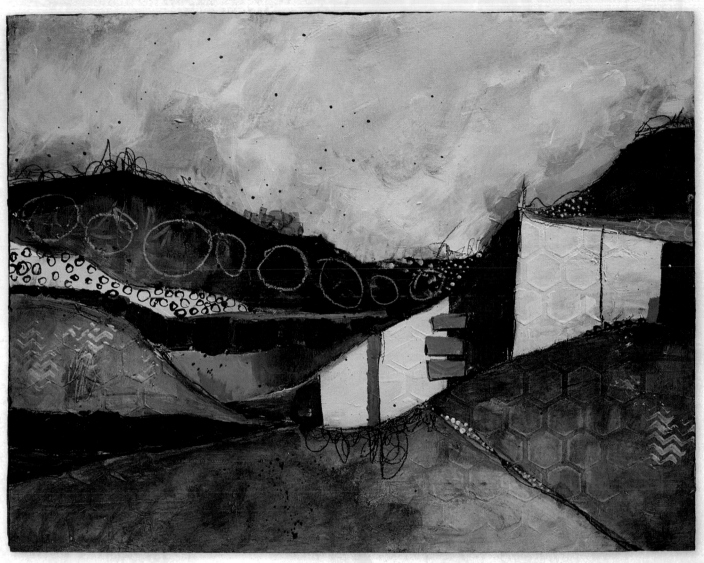

▲ **CROSSING BRIDGES**
11" × 14" (28cm × 36cm), acrylic,
stencils and collage on Gessobord

Painted Papers and Painting

IF YOUR MUSE HAS LEFT THE BUILDING, or if you are still fighting the fear of the blank canvas, spend a day mono printing and painting papers. It could be just the remedy you need. Since many of these papers and prints will be used in collage elements in upcoming chapters, you may want to work with one or two color palettes so that your papers work together nicely. Believe me, this is just the tip of the iceberg when it comes to techniques for creating painted papers. My hope is for you to be inspired and let go of any fear you may have of getting started!

Materials list

Assorted paints

Bristol paper

Deli paper

Dura-Lar matte film sheets

Dura-Lar mono printing plate

Glazing medium

Lightweight drawing paper

Scrap paper

Scraping tools, brushes and brayers

Spray bottle with water

Stencils and/or stamps

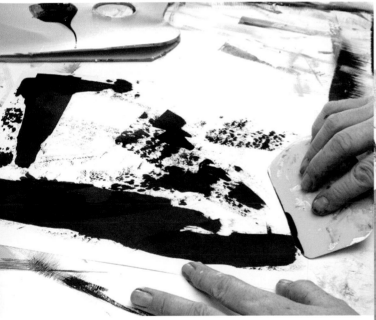

1 Start With Scraping Techniques
Load paint onto a scraper and drag it across the paper. Vary how you hold the scraper to create an assortment of textural marks. Start with a dark color (black or another dark shade).

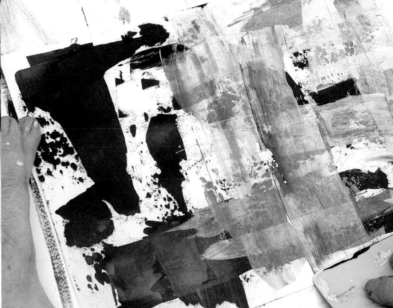

2 Scrape In a Light Neutral
Add white or another light-colored neutral and continue scraping, letting the wet paint mix together on the paper. The base layer should look similar to a weathered brick or cement wall.

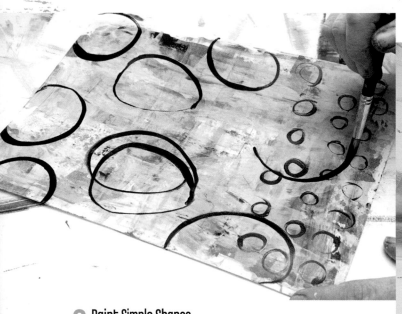

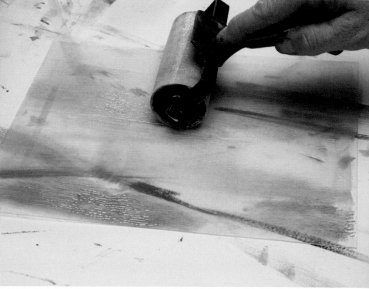

3 Paint Simple Shapes
Use a small brush to add simple shapes to the background. Continue using the small round brush to add smaller shapes in a loose, calligraphic manner.

4 Try a Printing Technique
Mix a small amount of glazing medium with paint, and roll it onto a mono printing plate with a brayer. Scrape into the wet paint to create patterns.

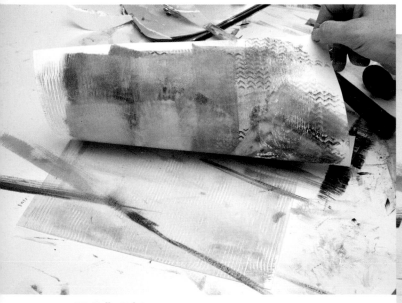

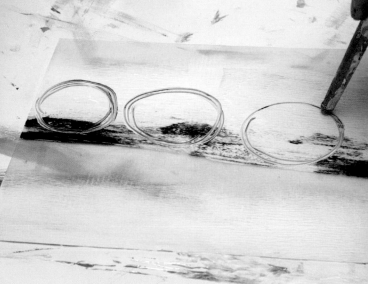

5 Pull a Print
Take a scrap piece of painted paper and press it onto the printing plate. Pull it up to reveal the print.

6 Draw in the Wet Paint
Add more paint to the printing plate, drawing in lines or patterns with a skewer or the back of your paintbrush.

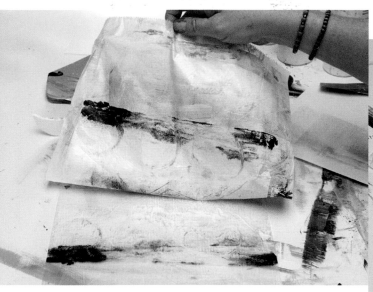

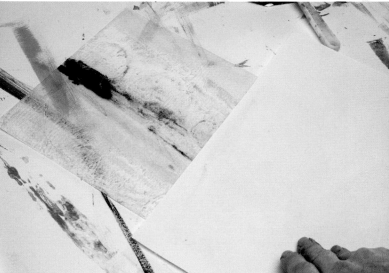

7 Pull a Print Again

Make a print with a different type of paper. Deli paper is a great choice for collage and journal projects because it is so thin. It is more durable than tissue but provides a similar look when collaged onto a surface.

8 Pull More Prints

Mist the printing plate with water. Take scrap papers and pull prints starting in different areas of the paper. This will create interesting overlay patterns on your print.

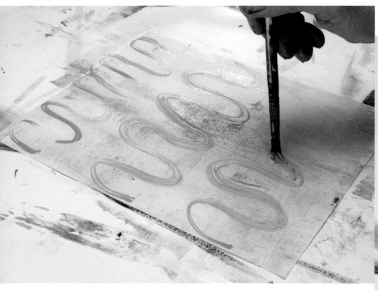

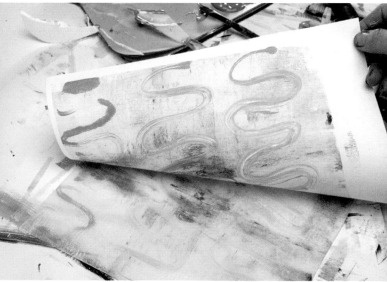

9 Paint New Patterns

Without cleaning the plate, continue to build up patterns using a contrasting color. If the paint dries quickly, mix it with a bit of glazing medium.

10 Pull Multiple Prints

Use inexpensive copy or drawing paper to explore the possibilities. You can make multiple prints at a very low cost and create your own stockpile of prints for future art pieces!

Creating Papers

It may be tempting to use many colors during your printmaking/paper painting sessions, however it's better to limit your palette and build a library of prints that coordinate with one another. Another advantage to limiting your palette is that you can mix paints and reprint several times before cleaning your brush or palette. Try new color combinations in each printmaking/paper painting session.

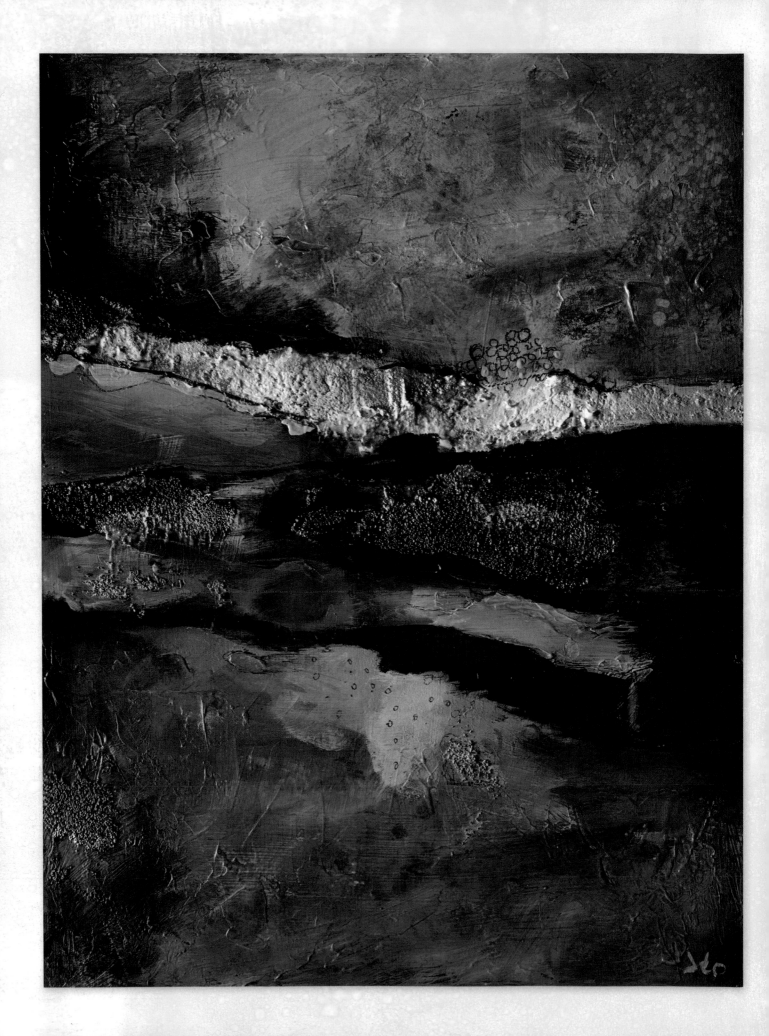

Art Inspired by Rocks and Patterns

AS MUCH AS I'M INSPIRED BY THE BEACH AND WATER, the warm comfort felt while driving through the mountains engulfs me with a sense of calm and security. Being surrounded by these mammoth shapes that tower over you is like getting a hug. There are patterns, colors and textures galore to draw upon for inspiration. In this next project the strata of rocks cut out to make way for a highway that I recently traveled through inspired me, but the finished painting came out more like a pathway leading through the desert at sunset. The beauty of abstract painting is that the viewer can take away whatever meaning or emotion he or she derives from a work of art. Your job is to infuse the emotion in the process of creating it in the first place. Don't be surprised if your art takes twists and turns that veer away from your original starting point.

Materials list

Assorted brushes

Assorted fluid acrylics: Gold, Quinacridone/Nickel Azo Gold, Pyrole Red, Sap Green, Titan Buff, Van Dyke Brown

Black gesso

Crackle paste

Fiber paste

Glass bead gel

Hardbord

Matte medium

Modeling paste

Palette knife

Sandpaper

Titanium White soft body acrylic

White chalk, black water-soluble pencil

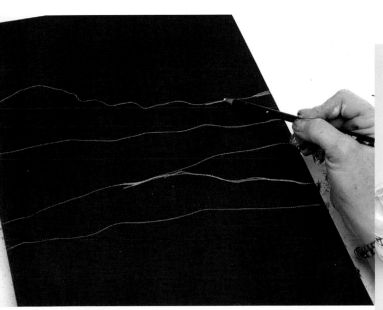

1 Paint With Gesso

Paint your Hardbord surface with black gesso and allow it to dry. Section off your surface with a white chalk pencil to re-create the strata of the layers of a mountain. Imagine driving along a highway where the mountains have been cut away to make room for the roads. Imagine an imperfect strata of layers, featuring earthy colors and textures.

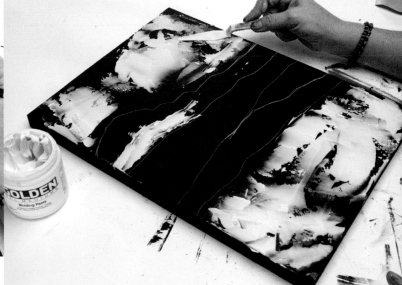

2 Apply Modeling Paste

Apply modeling paste into some of the sections with the palette knife. You want to be uneven with the application and encourage a variety of marks and texture.

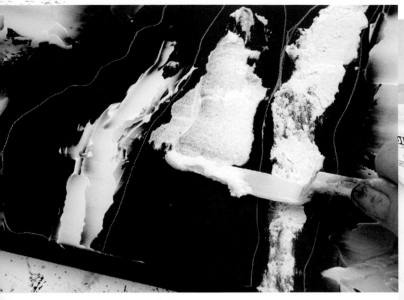

3 Apply More Mediums

Continue layering a variety of textural mediums in various sections. (Glass beads, fiber paste and crackle paint are just a few of the texture mediums available.) Your goal is to create the illusion of rough rock formations. Allow it to dry six hours or more. If the mediums feel cold to the touch or are tacky, they will need more dry time.

4 Create a Matte Medium Barrier

Once it's dry, gently sand off any loose medium pieces. Apply a layer of matte medium to provide an isolation layer between the surface and the mediums. Allow the matte medium to dry before proceeding.

The chalk lines might disappear as you're painting on the matte medium, but that's okay. You can redraw them later.

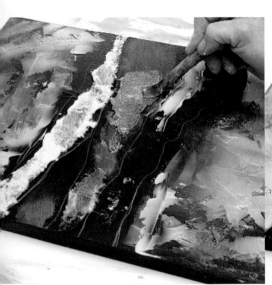

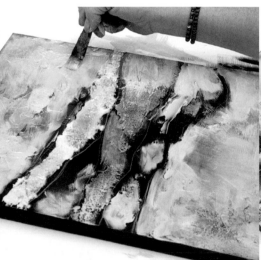

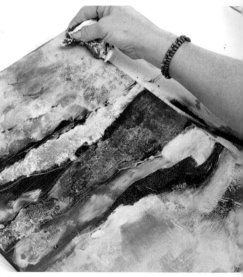

5 Start Painting With a Metallic Color

Begin building up the painting layers by starting with a warm, rich gold tone. The metallic color will also infuse light into the finished work.

6 Continue Painting

Use earthy tones for this composition since you're imitating nature. Draw inspiration from mountain ranges you've seen and the variety of colors that exist in the land. After you add Gold, blend Titan Buff with both a brush and your fingers to achieve an uneven but soft look.

7 Paint the First Layers of Color

For your first few layers of color, try not to overthink the application. Work quickly as you move around the piece adding different hues as you see fit. This helps to achieve a more natural look and to not feel forced. At this stage, use Quinacridone/Nickel Azo Gold and Pyrole Red. Blot up the wet paint to reveal interesting patterns.

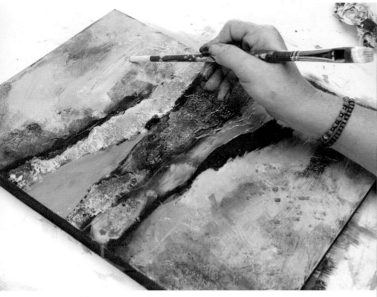

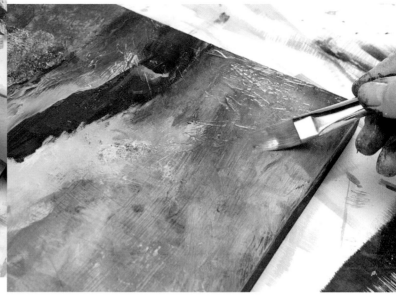

8 Add Brown to the Layers

Mix Van Dyke Brown with white and Titan Buff. Van Dyke Brown is a translucent color so it must be mixed with the other colors to appear on the black background. Scratch into the wet paint to create texture as you go.

Don't feel like you need to paint over the entire background. You can allow some of the black base to show through. Doing so adds to the dimension and suggests the separation of shapes.

9 Add a Glaze at the Bottom

Mix Quinacridone/Nickel Azo Gold with Van Dyke Brown to get a warm dark brown mixture. Spray water over the piece and pull up the color with a paper towel. Glaze over the bottom of the substrate with a Sap Green and glazing medium mixture to suggest grass.

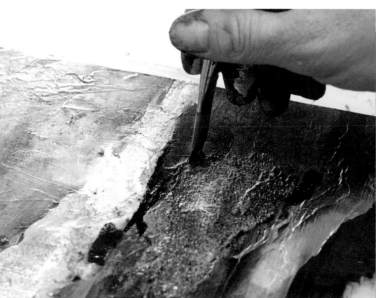

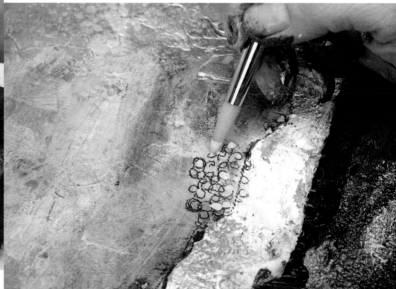

10 Continue to Add Layers

Continue to build up the colors and textures until you are satisfied. You can employ many, if not all, of the processes discussed in previous exercises. To add more defined lines between the sections or shapes that emerge, outline them with black paint.

11 Final Details

Add final details with pencils or other drawing medium. Draw small rocks and circles. Evaluate your work and incorporate contrasting colors, if needed.

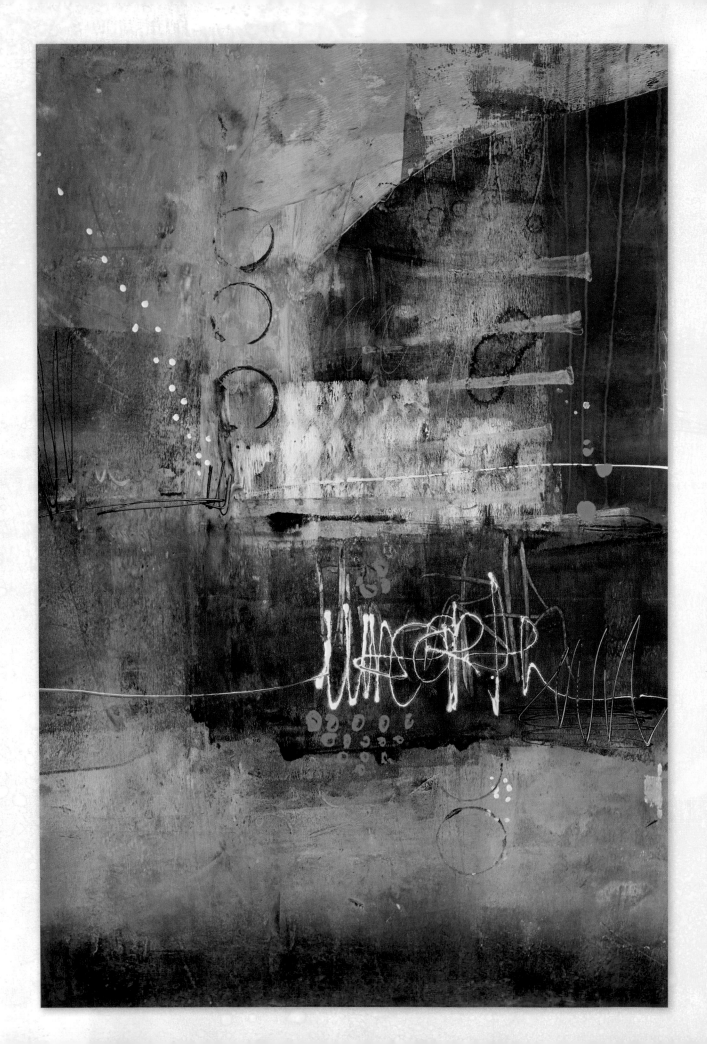

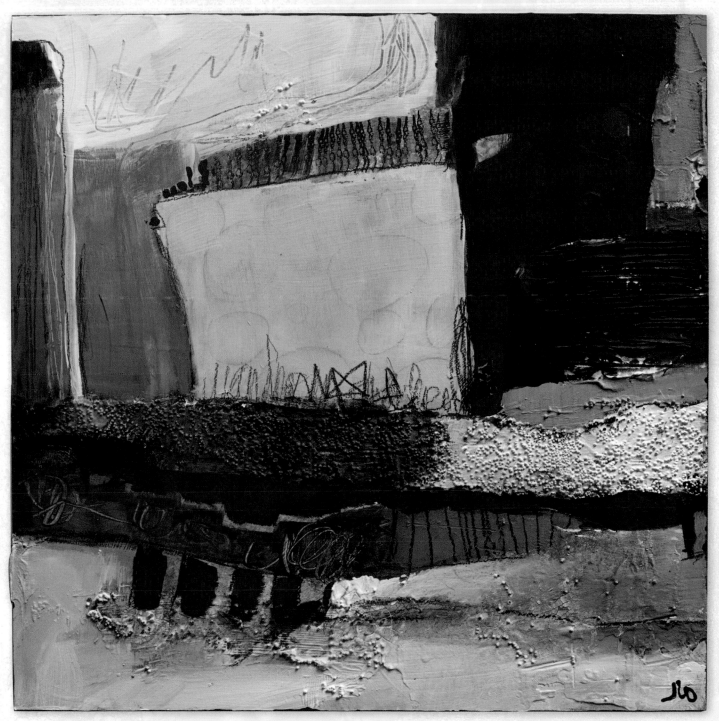

▲ THE MAZE
12" × 12" (30cm × 30cm), acrylics, textural mediums, drawing mediums on Ampersand Hardbord

◄ UNEARTH
11" × 17" (28cm × 43cm), acrylics, ink and drawing mediums on Yupo paper

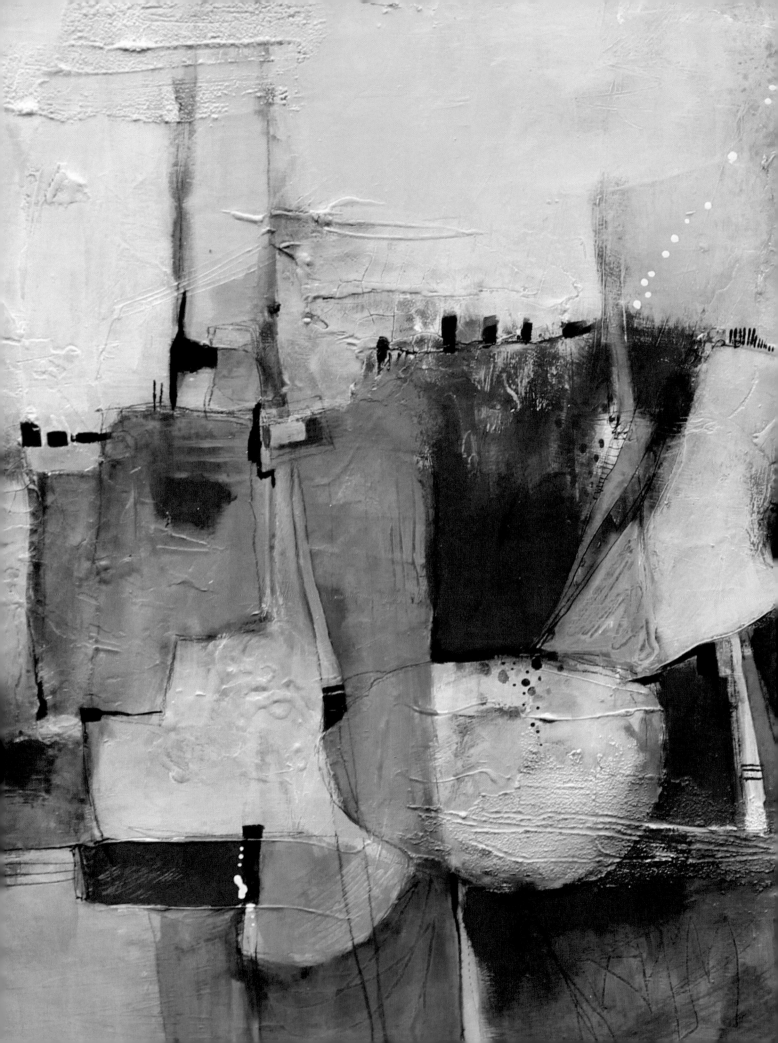

4 Putting Your Skills to Work

I'D LIKE TO THINK OF THIS BOOK as a resource that encourages you to put your skills to work in manageable ways through exercises and skill builders. When I'm working on larger paintings in my studio, I use many of the mediums we've featured in the previous demonstrations, some more so than others. I also tend to favor a certain color palette for a period of time before moving on to something new. Why I choose to do what I do is not easily explained. The best metaphor I can share is one of cooking. At first you use a recipe to guide you in making a dish. After a few tries, you become brave and add your own signature ingredients, maybe even throw in something that leaves your tasters wondering what magical ingredient makes your dish so wonderful. When is your dish (painting) finished? It can't always be timed, although you'll eventually know just by looking and touching.

Over time, you will know exactly what colors to reach for and which supplies to use instinctively. Sometimes letting go of any fear or expectations you have for the outcome are the key ingredients. The recipe for success will reveal itself to you as you roll up your sleeves and get busy. Be patient. You'll create some clunkers. We all do. Sometimes the clunkers are great beginnings that you haven't finished yet. The patience required of an artist is enormous, so give yourself a break from time to time to refill your well and gather inspiration for those days when you aren't feeling up to the task.

On Success and Creativity

"Creativity comes from trust. Trust your instincts. And never hope more than you work."

— RITA MAE BROWN

Sources of Inspiration

CREATING YOUR OWN PERSONAL LIBRARY of inspiration can come in many forms. It may entail a daily habit of photography on a quiet morning walk or a visual diary from a vacation to an exotic location. What kinds of things spark inspiration? Here are just a few off the top of my head, unusual patterns occurring in the bark of a tree, the weathered paint layers from an old building or a color combination from a patch of wildflowers. Any of these sightings (and countless others) may strike an idea for future use in your work.

The most important thing you can do is to be observant. Find a way to catalog your inspirational discoveries so that they'll be available to you when you're ready to use them in your art. Remember your jumping off points of inspiration are just that: It isn't necessary to replicate an entire photograph you've taken. You may find inspiration in a shape or pattern you come across in just a part of your photo that leads to a bigger idea. Be open to it all.

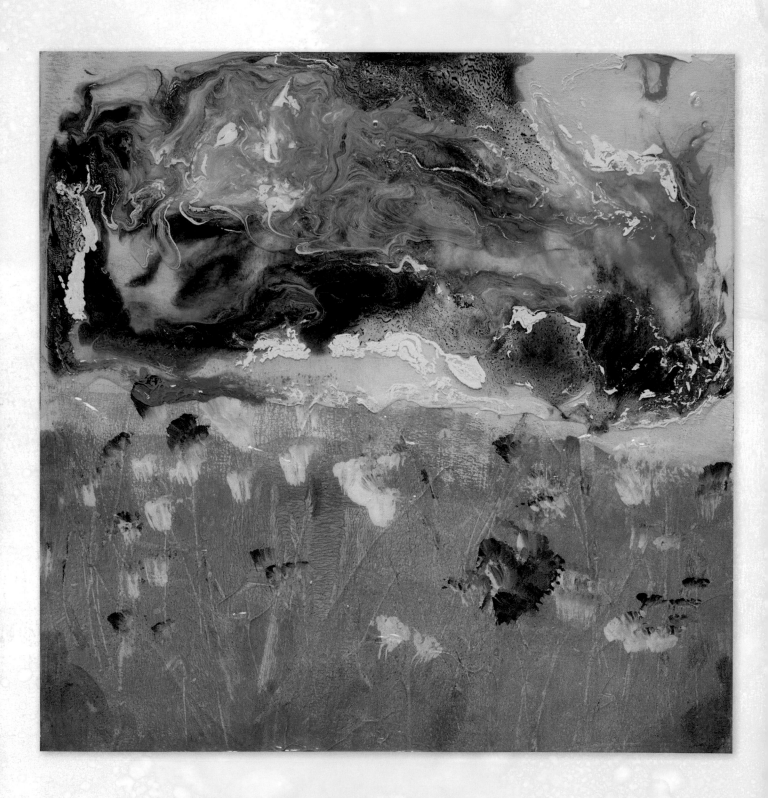

Creating a Landscape Using Acrylic Mediums

Materials list

Assorted acrylic paints: Titanium White, Quinacridone Magenta, Teal, Green Gold

Brayer

Brushes

Cradled wood substrate

Painter's tape

Palette knife

Pouring medium

Soft gloss gel medium

White gesso

DRAWING FROM AN INSPIRATIONAL WALK I've taken many times, this demonstration represents a more impressionistic abstract style of painting. The forms are clearly identifiable as flowers, grass and a sky, but the dreamlike quality is achieved by layering acrylic mediums over the main composition. In many ways this technique is similar to working in encaustic painting. While this sample requires only two layers of medium, you may be compelled to add even more. I say be fearless and go for it!

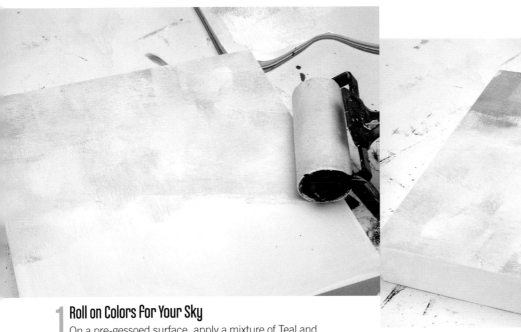

1 Roll on Colors for Your Sky
On a pre-gessoed surface, apply a mixture of Teal and Titanium White with a brayer to the top portion of your composition. Leave some white areas to suggest clouds in the sky.

2 Create a Horizon Line and Grass
Repeat the process below the horizon line with Green Gold, suggesting a grassy meadow. Use the side of the brayer to scrape into the paint to create spikes of grass and flower stems. If you like, repeat with another layer of Green Gold in a different hue (add white or a touch of black to lighten/darken the grass).

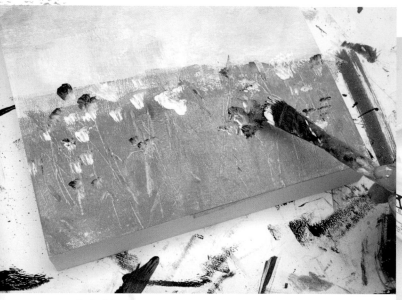

3 Dab in Flowers

Loosely mix Quinacridone Magenta and Titanium White on a flat brush. Dot the lower two-thirds haphazardly to give the impression of a field of flowers. Allow the paint to dry.

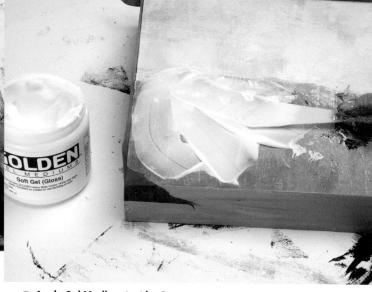

4 Apply Gel Medium to the Grass

Apply painter's tape to the edges of the canvas to keep the next layer of mediums in place. With a palette knife, apply a healthy amount of gel medium to the bottom portion of the substrate. The gel will shrink a bit so use more than you think you need. It will also dry clear so you will see the underlayers.

5 Clean the Edges

Wipe any residual gel medium from the sides of your surface.

6 Add Pouring Medium to the Sky

Starting in the center of the top of your surface, add pouring medium. Tilt your surface so the medium flows over the sky area.

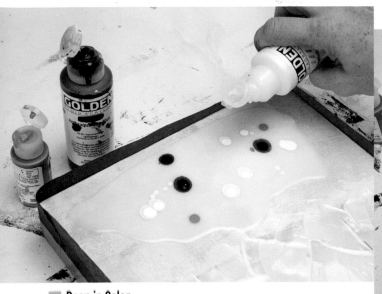

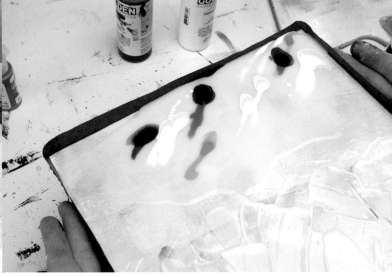

7 Drop in Color

Drop fluid paint colors into the pouring medium while it's still wet. Use whatever colors remind you of a sky (white, pink, blue, gray).

8 Tilt the Surface

Continue to tilt the substrate to encourage the paints to flow together.

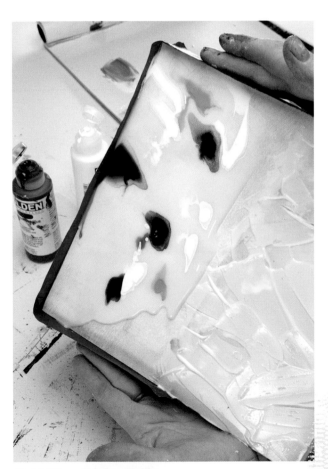

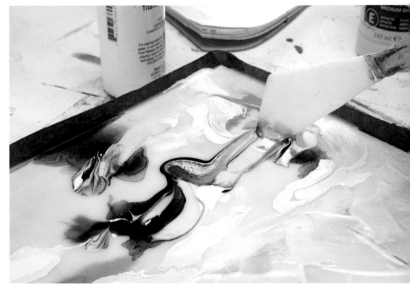

10 Mix the Colors More Thoroughly

Use a spatula or palette knife to marble the colors slightly. The surface design will change as the medium and paints level. Allow it to dry a minimum of twenty-four hours on a level surface, away from any dust or potential debris (such as animal hair).

Create More Dimension

To create even more dimension, add another layer of paint when the texture medium and pouring medium have dried. Paint a few more flowers in the grass with a new color. Let it dry. Then seal the entire surface with one last layer of soft gel medium. The result will look almost three-dimensional!

9 Add More Color or Medium

Add more pouring medium and color, if needed. Continue tilting the surface and moving the medium and color around the top portion of the piece.

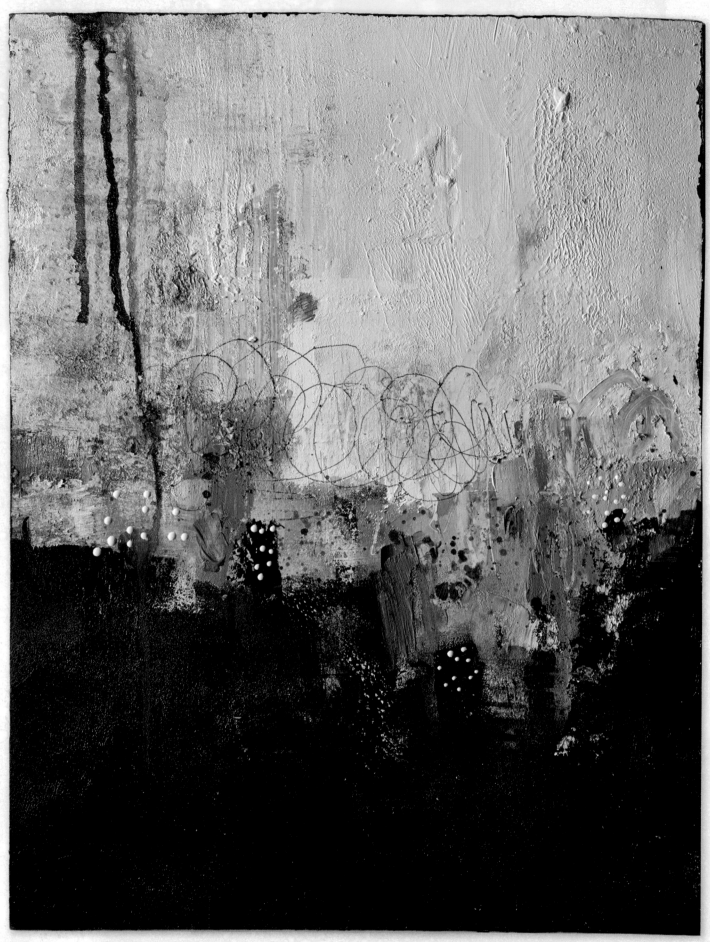

Demonstration

Creating a Landscape With Texture

MY GO-TO PAINT HAS TRADITIONALLY BEEN FLUID ACRYLICS, however, lately I've rediscovered the joy of soft and heavy body paint. The creamy consistency and the feel of the paint softly caressing the canvas is a rich experience to behold. Because of the paint's high viscosity, it's easy to make marks and lines that hold their shape. For this particular painting, my inspiration was the melding of a simple traditional landscape with the backdrop of a gritty cityscape. Keep it simple and play with creating textures with just your paint and the tools you have at hand.

Materials list

Assorted brushes

Assorted heavy body paint: black, white, Warm Gray

Assorted soft body acrylic paints: Quinacridone Magenta, Carbon Black, Australian Blue

Brayer

Catalyst wedge and blade

Fineline applicator filled with Titanium White fluid acrylic

Gesso

Glazing medium

Hardbord panel

Jerry's Jumbo Jet Pencil

Spray bottle

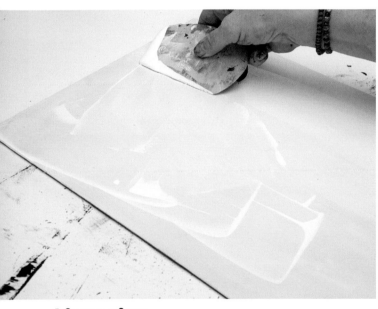

1 Scrape on Gesso
Prime your surface with gesso using a catalyst wedge or a scraping tool. Using a scraper will create lines of texture.

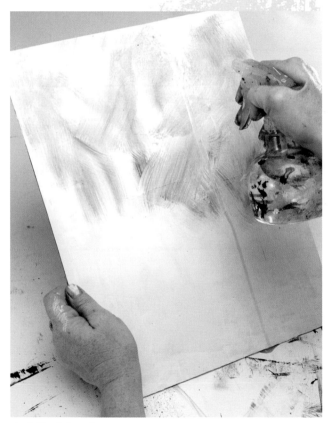

2 Add a Color Glaze
Mix a glaze of Quinacridone Magenta and glazing medium. Randomly brush on the mixture to the top portion of your landscape. Spray water onto the surface while the board is tilted to allow some of the color to run down. Blot excess color.

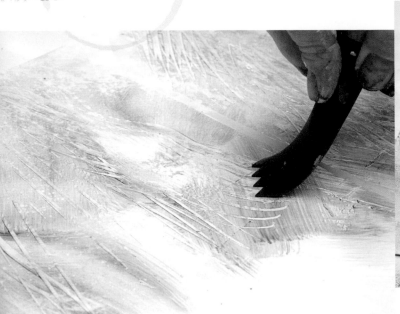

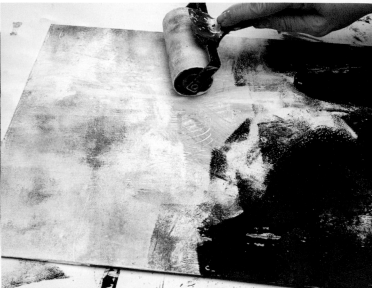

3 Scratch Into the Glaze
Use a catalyst blade to scratch into the glaze layer while it is still wet.

4 Build Layers With Heavy Body Paint
Use heavy body black acrylic paint to cover the base of the surface. Roll it on with a brayer. Change directions as you roll and spread the paint around. Paint over some of the magenta as well, but use a lighter hand so it will still show through.

Continue to use heavy body paint to build up the surface. Squirt out some white directly to your substrate above the horizon line. Use a dirty brayer or mix a little black into the white in order to encourage value shifts. Change directions with your brayer to build up shapes. Scrape into the paint with your blade again. Let dry and repeat these steps to build layers.

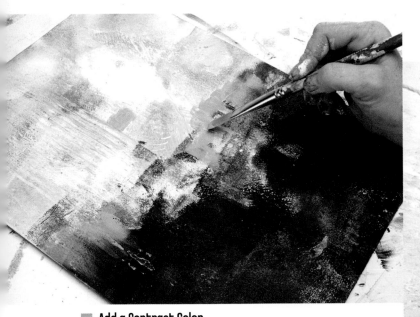

5 Add a Contrast Color
Bring in a contrasting color using a small brush and Australian Blue to add small random sections of blue. Hint at a skyline or cityscape. Because it is an abstract, you are creating a mood rather than a perfect representation. Perhaps it will be a rainy foggy day in the city.

Continue building up the layers and adding abstract shapes.

6 Dig Into the Paint
As you are building up the paint layers, use your mark-making tools to dig into the heavy body paint. This will create a weathered and worn look of texture.

7 Define the Bottom Section

Alternate between using a brayer and a scraper to add paint. You want to encourage a variety of interesting shapes to emerge. Using multiple tools in addition to brushes will assist in accomplishing this process. Warm Gray (which resembles putty) adds a neutral hue to the composition. Finish the bottom with black fluid acrylic. This will flow nicely over the heavy body paint and add dimension to your layers.

8 Drip Paint Down the Surface

Tilt the panel and add paint to the top of the surface with a wet brush, or spray the paint with water to encourage it to drip. The colors will comingle as the paint drips down the panel.

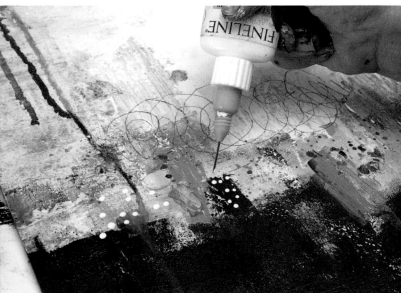

10 Final Details

Finish your detail work by using the Fineline applicator to suggest lights, windows, buildings or patterns you'd like to draw attention to in your composition.

9 Add Splatters and Scribbles

Splatter several of the paint colors you've already used to tie the work together. Use a Jumbo Jet Black pencil to draw designs and marks.

Try a Variation

Consider repeating this landscape using the same color palette but emphasizing a different color within your palette each time. You'll be on your way to creating a great collection!

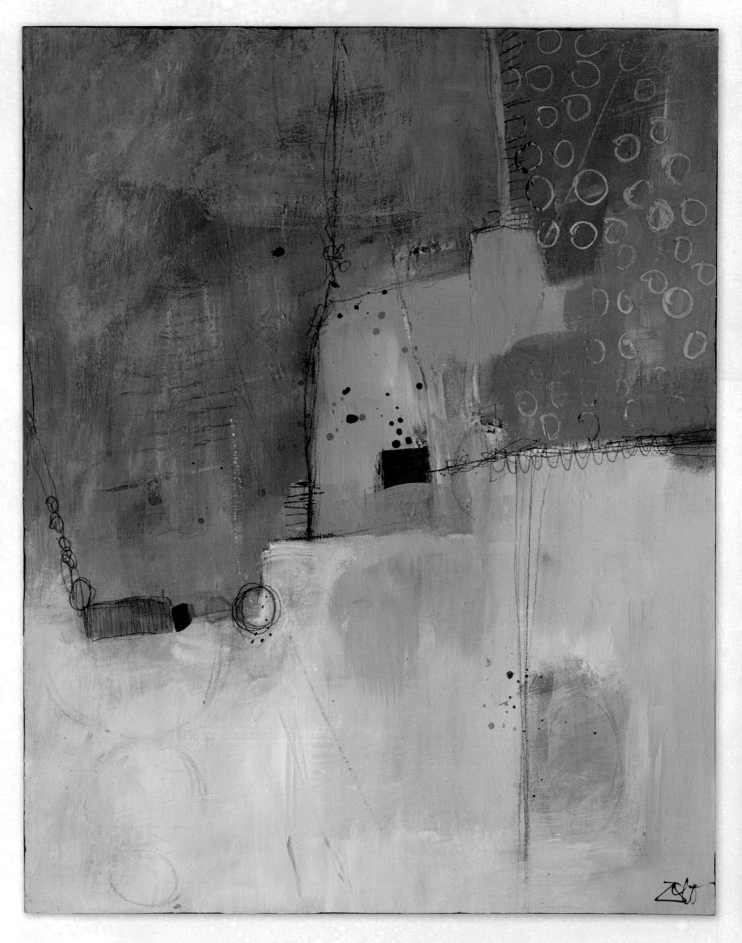

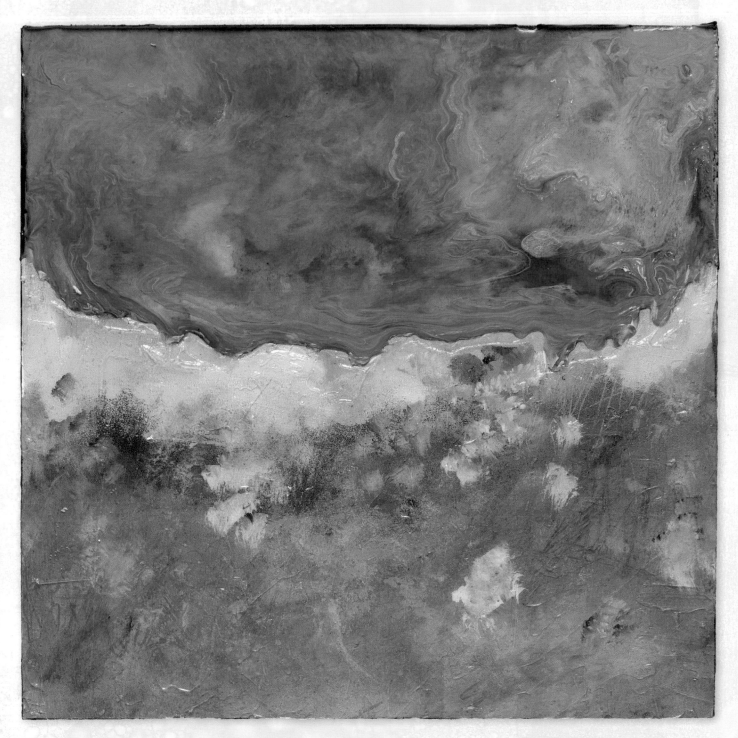

▲ **FIRST DAY OF SPRING**
12" × 12" (30cm × 30cm), acrylics, gel medium,
pouring medium on Ampersand Gessobord

◄ **CIRCLING BACK AROUND**
11" × 14" (28cm × 36cm), acrylics, charcoal,
pencil on Ampersand Hardbord

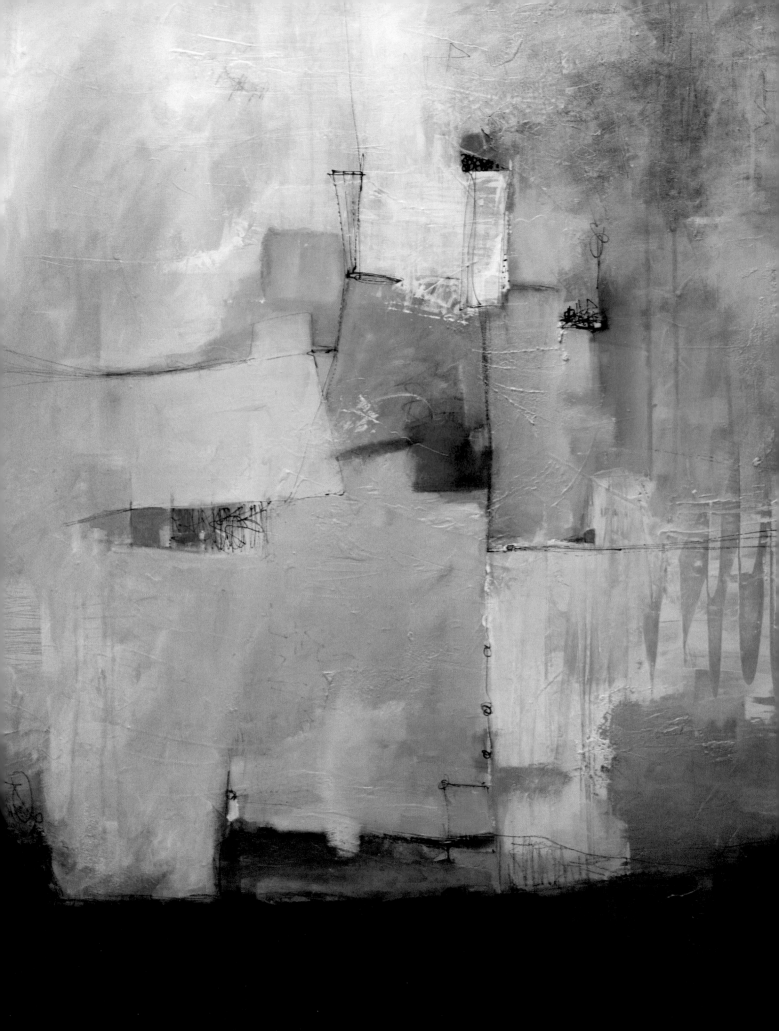

5 Exploring Shapes and Patterns

LEARNING HOW TO BOTH SEE AND CREATE organic and geometric shapes in your work is a beneficial skill to have in the process of making a successful abstract painting. On the outside looking in, it may appear that you are splattering and brushing on paint without a second thought, but those of us who paint abstracts know that the process, while freeing, actually requires the ability to problem solve. Artists must control the chaos while at the same time be willing to let go of areas and allow pieces to freely develop. When in doubt, refer to the rules of engagement—the elements of art and the principles of design—and then let your instinct take over. Once you let your passion come through, you'll see magic dancing across your canvas.

On Variety
"The essence of the beautiful is unity in variety."
— WILLIAM SOMERSET MAUGHAM

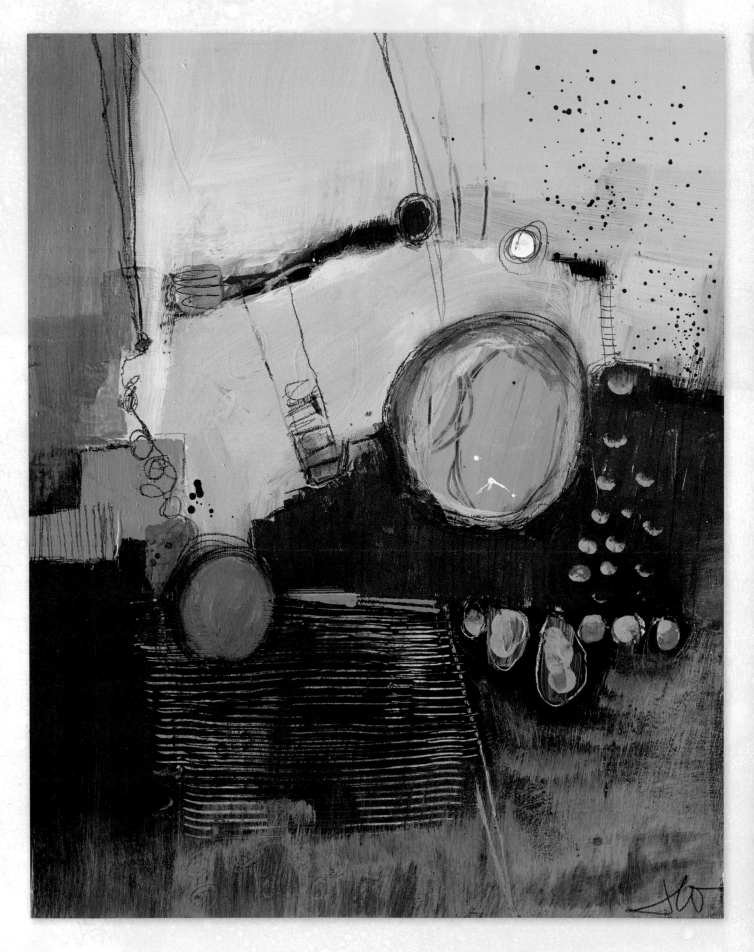

Simple Grid Form

Materials list

Assorted fluid acrylics

Assorted soft body acrylics

Black gesso

Brushes

Glazing medium (optional)

Hardbord

Matte medium

Neocolor II water-soluble crayons

Paper towel

Pencils

Scraping tools

White paint marker

THIS GRID FORM MAY OR MAY NOT BE SIMPLE for you to replicate, and believe it or not, that's perfectly okay. Not every painting takes ten minutes to create. A lot of joy can be found by immersing yourself fully in the experience. The premise of this exercise is simple, find and paint shapes over and over again. The complexity comes from knowing how to make those shapes work together to tell a story or to intrigue the viewer (and yourself). Moving from beginning to end can take several twists and turns. My advice to you is to allow the painting to unfold as naturally as it can by proceeding with your first instinct. Each brushstroke will require a new decision across your canvas. Be prepared to let go many times over.

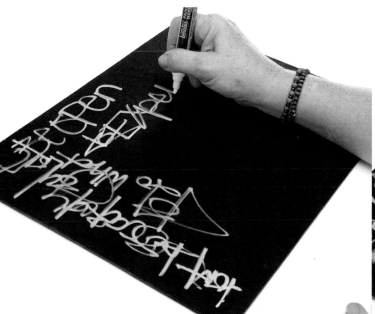

1 Paint a Gesso Base and Write

On a Hardbord surface, apply black gesso as your base. Once dry, take a moment and just let your feelings flow onto the surface by writing all over it with a white paint marker. While most of the words will fade away by the time you are finished, this jump-start will help you get in tune with the emotion of your painting.

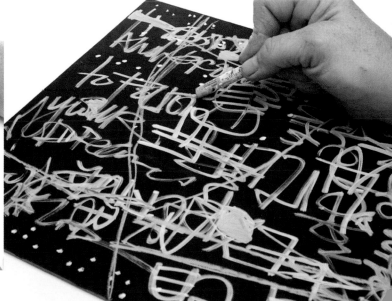

2 Draw Grid Guidelines

Using a Neocolor II crayon, create a grid with horizontal and vertical lines. The shapes you create don't have to be symmetrical or perfectly straight. These shapes will serve as your guidelines initially, but you must remain flexible since your painting will transform as you build your composition. Don't limit yourself to just one viewpoint. Feel free to turn the surface to find other interesting shapes and lines.

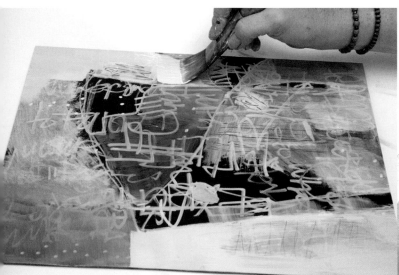

Sometimes Dirty Is Better

Don't feel like you must clean your brush. A dirty brush can give you interesting mixes of colors as you paint.

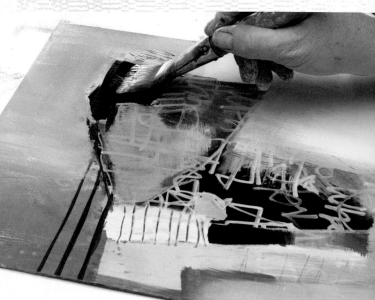

3 Start Blocking in Color

Brush on the first pass of color using both soft body and fluid acrylic paints. Block in some of the areas with another color to create shapes and establish the initial design. Wipe off excess paint with a paper towel as you go to create texture in certain areas. You can also mix glazing medium into your paint to create translucency.

4 Continue Painting

Continue working around the surface, blocking in color. Try to vary the values by including some lights and darks as you work.

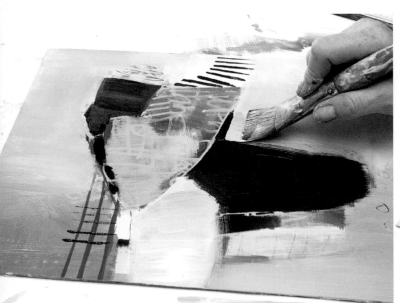

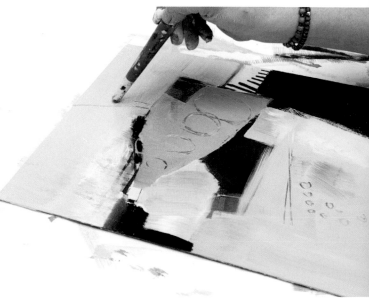

5 Create Hard and Soft Edges

As you work with the composition, include a variety of hard and soft edges for visual interest. You can create soft edges by lightly feathering your brush outward as you're painting. Use the flat part of your brush to create hard edges and patterns.

6 Draw Into the Wet Paint

Mix matte medium and white acrylic, and paint a veil over various sections. Draw patterns into the wet paint by using your brush. Finish the first pass of color. Look for areas that need more definition and fill them with color.

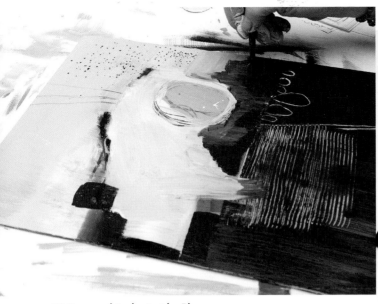

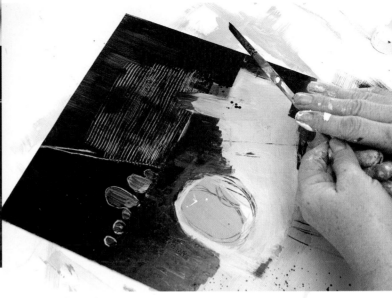

7 Turn and Evaluate the Piece

Evaluate your work by turning it around and viewing it from a different perspective. Choosing a new color to feature may be the answer to finalizing it. Scrape into the wet paint to create texture.

8 Add Paint Splatters

Splatter paint and create patterns and shapes with a smaller brush. Let it dry.

Words of Wisdom

Don't become too tied to the original grid. Things can change on the piece depending on your mood or what you're feeling as you create. Continue to build up the layers of paint, and work around the piece. Allow it to evolve organically.

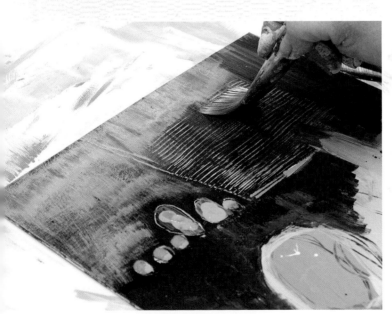

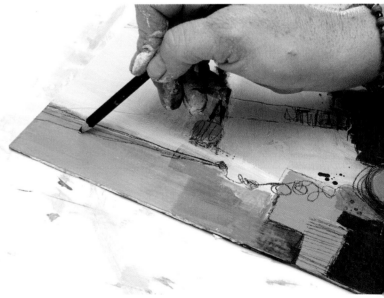

9 Tie the Sections Together

Drybrush a color from the top of your surface across the bottom edge of the piece to help tie both areas together visually. You can still see the underlayer beneath the dry brushing.

10 Final Details

After this first pass of color and shape of the overall design is finished, go back in and redraw your shapes. Use the crayon, paint marker or pencil. Blend pencil with your finger to achieve a touch of shading. Add patterns and other line work. Turn the piece around and examine your work from all angles. In particular consider the balance of color and patterns. Add the final details needed to complete your piece.

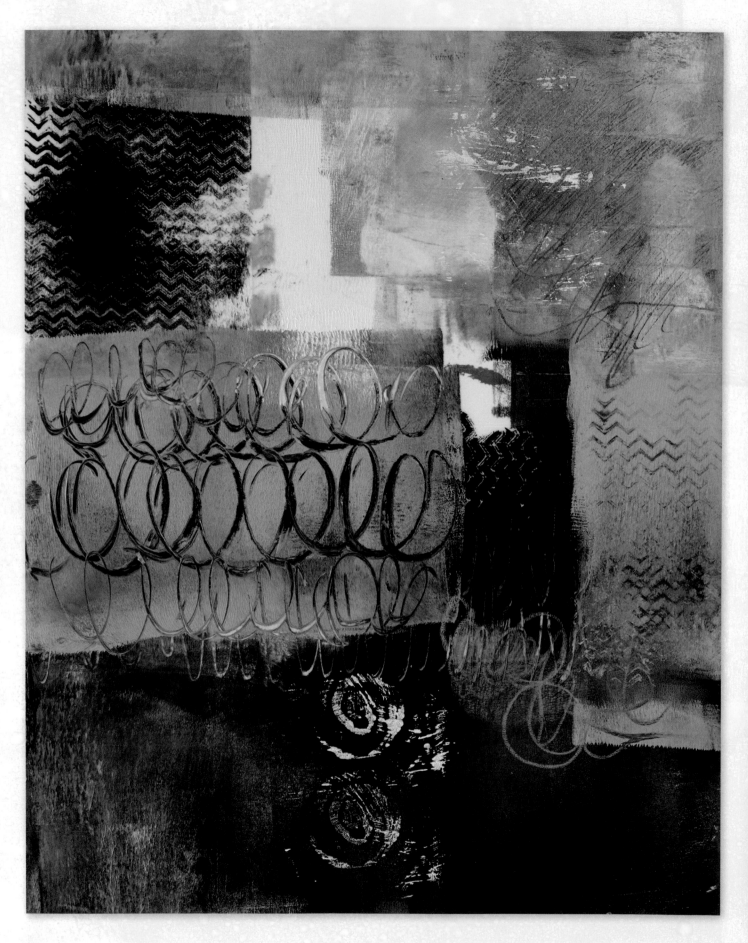

Creating Patterns and Grids With Dura-Lar

Materials list

Assorted soft and fluid acrylic paints

Brayer

Deli paper

Dura-Lar matte wet media sheets

Neocolor II crayons

Old pen for scraping paint

Stamps or stencils

Textured foam sheets

DURA-LAR PAPER IS AN ACETATE ALTERNATIVE. It comes in either a matte or clear film and can be used with both wet and dry media. Using similar techniques featured in the painted papers and printing section, your goal is to create grids and patterns using a brayer and stamps. As you layer colors and roll paint over existing shapes, patterns and grids should emerge in a very short time. This paper is also a great surface to scratch into, so dive in and make marks as you put your own unique stamp into the surface.

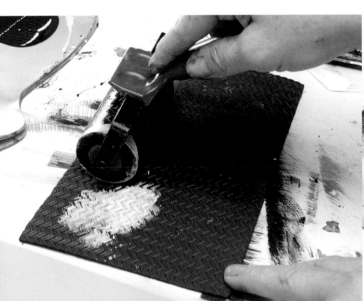

1 Roll Patterns Onto the Brayer

Add swatches of paint onto the Dura-Lar surface with a brayer. Roll your brayer into your chosen paint to load it with color, then gently roll it on a textured foam sheet for one rotation to imprint the pattern onto the brayer. Use just enough paint to pick up texture but no so much that it squishes all over the pattern.

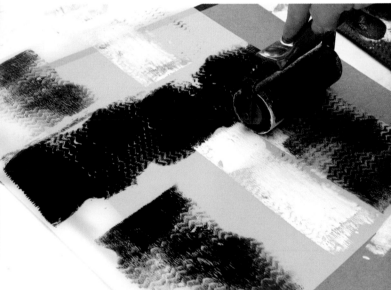

2 Roll the Marks Onto Your Surface

Roll the brayer onto the Dura-Lar surface to reveal the marks from the foam. Continue working the brayer until the paint is released. You may want to add another color for variety.

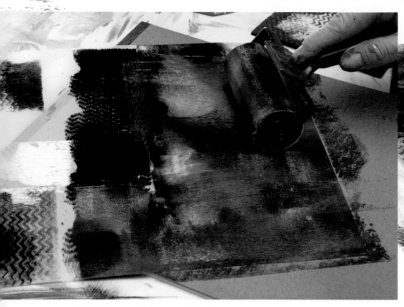

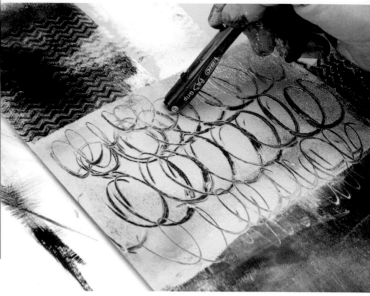

3 Continue Rolling on Paint

Work around the piece rolling on paint in multiple areas. Change the direction you roll or the size of the paint streak. Roll with the edge of the brayer or with it at an angle. Play with shapes and sizes as you roll the brayer. The colors you choose will change the overall look as you continue to build the composition.

4 Add a Contrasting Color

Add a wide opaque layer in a contrasting color. Pull up the wet paint with the back of an old pen by making circular motions.

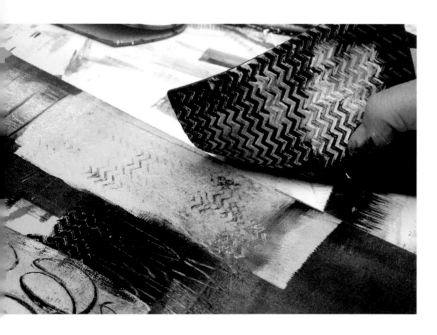

5 Create More Texture

Print with the foam textured block directly onto your surface. Stick to a limited color palette to ensure you don't make mud with the layering of wet paint.

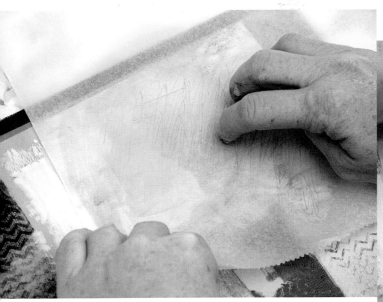

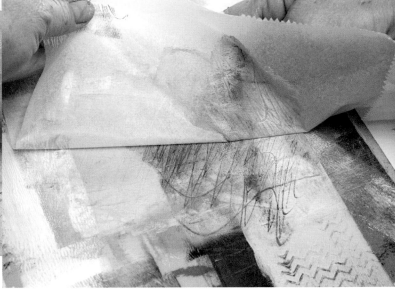

6 Mark Up the Surface
While the paint is still wet, try placing a piece of deli paper over certain areas and scratching the back of the paper to mar your surface.

7 Reveal the Design
Gently lift the deli paper to reveal a unique design made from the scratch marks.

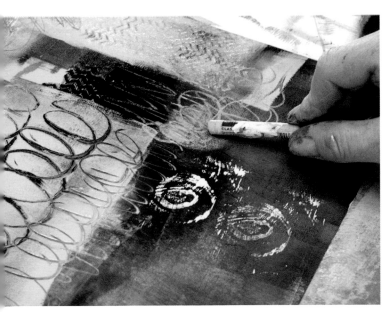

Keep Experimenting
You can repeat all of these steps as often as you like. The key is to limit your palette so that you create a sense of balance and a sense of unity by repeating similar patterns and shapes throughout your work. Be fearless and experimental in how you create textural marks in your work!

8 Final Details
Continue to play with line work by adding scribbles, patterns or shapes with a Neocolor II crayon. Add stamps or other stencils to complement your work.

Demonstration

Cityscape

IMAGINE DRIVING INTO A CITY AT DUSK, approaching
that last curtain of light. You're on the bridge and can see
building after building in the distance. What's the first
thing you notice? Is it the lights glowing from all the bus-
tling activity? Is it the slight reflection of shapes bouncing
off the water? Can you see the stars dancing in the sky?
Your view of a city need not be literal. Feel free to take
your own liberties on what you actually see or feel when
drawing upon this imaginary composition. The challenge
is to remain loose without losing sight of your vision.

Materials list

2 Claybord tiles

Assorted brushes, flat and round

Faber-Castell Pitt Artist Pen, fine tip

Fluid acrylic: Carbon Black

Glazing mediums

Golden high flow acrylics: Carbon Black,
Diarylide Yellow, Payne's Gray, Pyrole
Red, Shading Gray, Titan Buff, Turquoise

Golden high flow dauber tip

Scraping tools

Spray bottle with water

Stabilo water-soluble graphite pencil

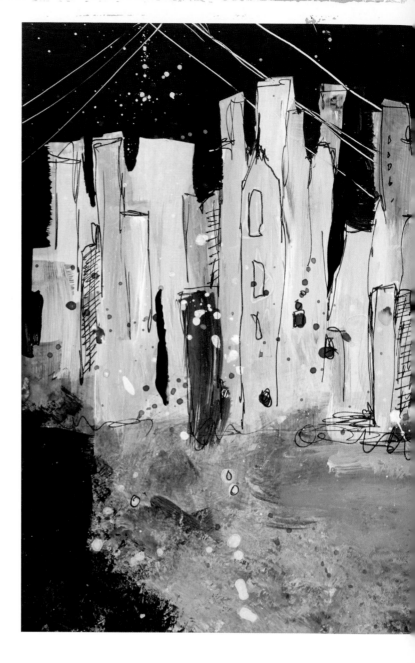

1 Define the Horizon Line

Establish where your city will appear on
the landscape. Paint a bright yellow sky
and a neutral gray below the horizon line,
where the water will be. The yellow will give
you a sense of light from the buildings once
the panels are complete. Since Claybord
is a very porous surface, you may have to
apply several layers of paint to build up a
solid background.

Spray water over the surface, and pick
up some of the paint with a paper towel.
Work around the piece. Rub the paint in,
add texture by making marks with your
brush, pull up color. Be loose and have fun!

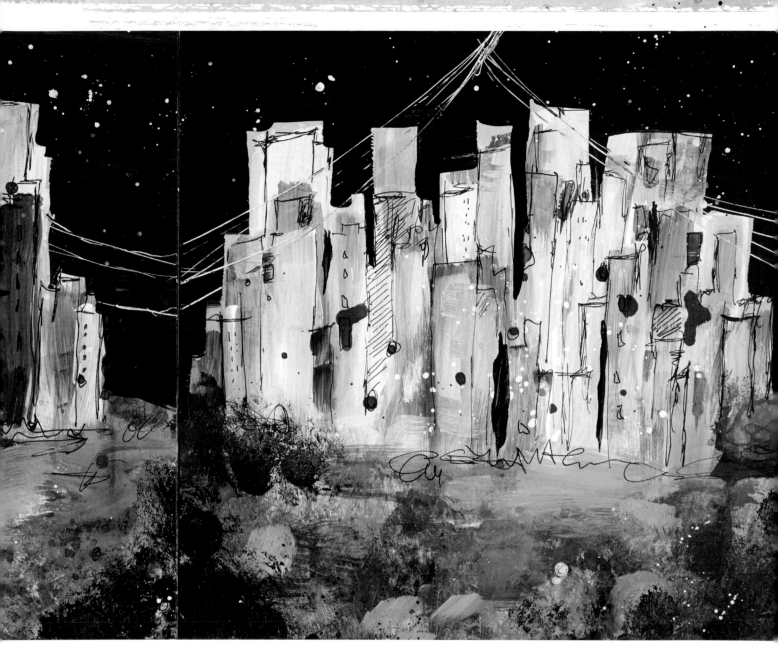

2 Sketch the City Shape

Use a sharp Stabilo water-soluble graphite pencil. Very loosely draw a cityscape onto the surface. Focus on rectangles and squares, the suggestion of city buildings. Vary the sizes of the shapes, overlapping some to create a sense of depth. Keep it simple and abstract.

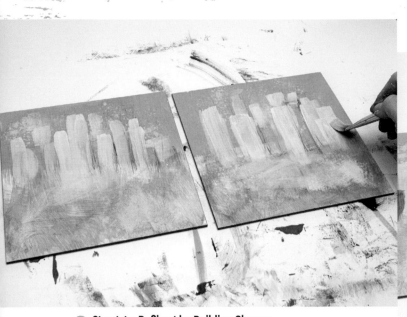

3 Start to Define the Building Shapes

Start with a light mixture of Titan Buff and build up a layer of color inside the building shapes.

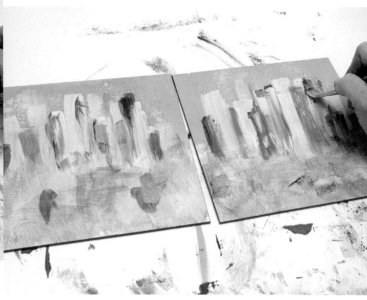

4 Add to the Buildings

Water down Payne's Gray and add to your city shapes. Add a touch of Payne's Gray to where your water is located to suggest shadows and the reflections of the buildings.

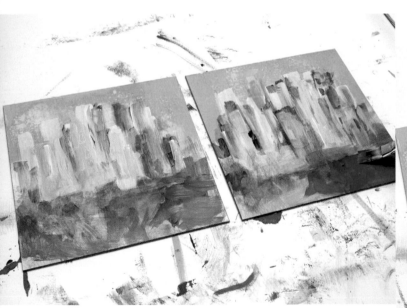

5 Start Developing the Water

Begin developing your water with loose strokes of color in Turquoise. Add some of that color into the buildings as well for additional shading.

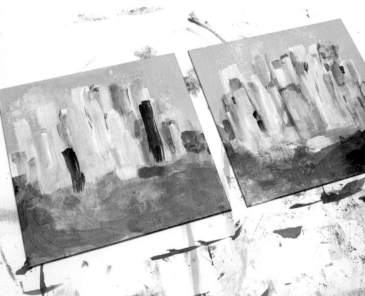

6 Add Pops of Red

Add a bit of red to suggest the warm glow of signs in the night skyline. Darken the water with another layer of Payne's Gray. Blend with a paper towel to soften the look.

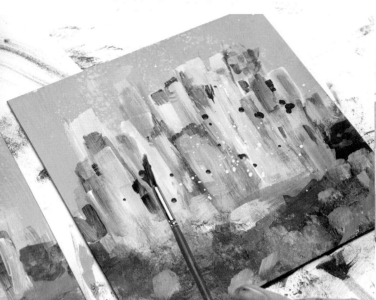

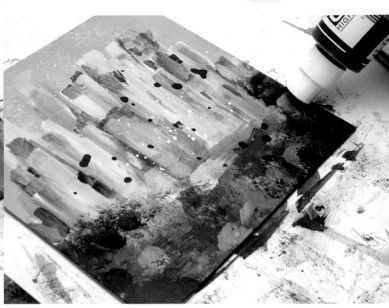

7 Add Paint Splatters

Play with paint splatters. Allow the splatters to land all over the two pieces.

8 Add Depth to the Water

To add depth, use a Golden high flow bottle with a dauber tip attached to dab some black paint into the water.

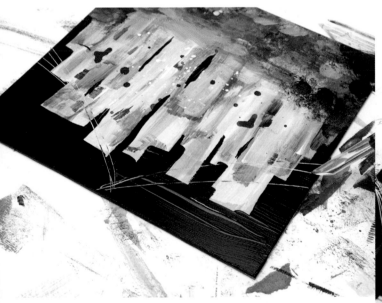

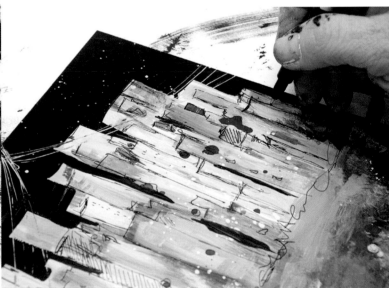

9 Darken the Sky and Block Out the Buildings

Mix a glaze of Carbon Black fluid acrylic and glazing mediums. With a flat brush that has a crisp edge, paint around the buildings, allowing some of the yellow background to show through. Add some black in between a few of the shapes.

Take an old pen or the back of a brush and draw lines into the wet black paint, scraping away the paint and suggesting bridge wires that connect the two panels. Imagine looking at the city from the other side of the bridge.

10 Final Details

Add white splatters over the black sky to suggest stars. Let dry. Finish the details of windows, doors and other shapes with a Faber-Castell Pitt Artist Pen with a fine tip.

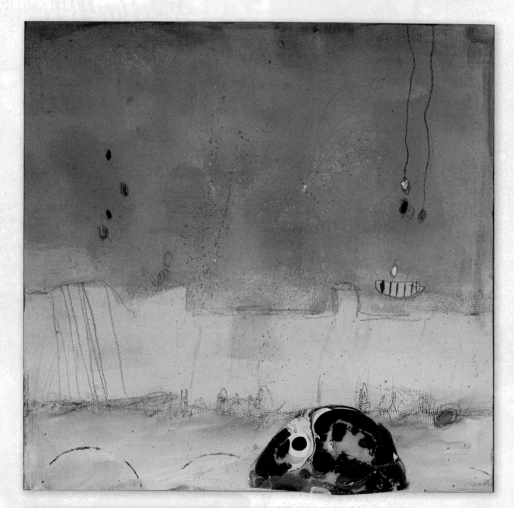

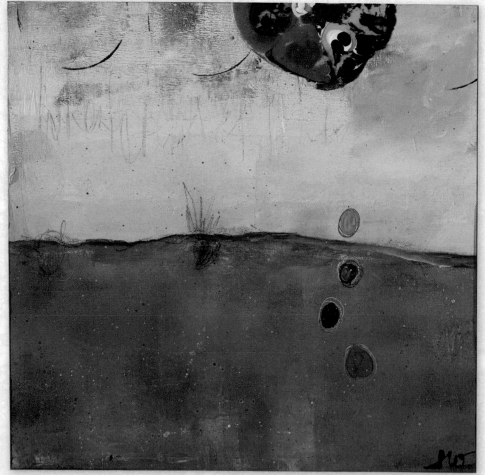

Circle Abstract

I FIND IT CHALLENGING TO WORK IN A MINIMALIST FASHION. I tend to want to add more and more and more, and before you know it, my "minimalist" project resembles a free expression intuitive style. I say it's okay. Whatever you are drawn to do, allow it to materialize in your art. It's hard to force a style. This next exercise employs more restraint than I usually use in my compositions. Unity is created through the repetition of colors and shapes. This is also a great opportunity to use the acrylic skin you created in Chapter 2 as a collage element. The skin also inspired the color palette for this particular diptych.

Materials list

3-4 fluid acrylic colors: Diarylide Yellow, Permanent Violet Dark, Green Gold (influenced by the colors in the acrylic skin)

Acrylic skin (from previous demonstration)

Brayer

Gessobords

Large flat brush

Scissors

Smaller detail brushes

Soft gel medium

Soft body Titanium White

Water-soluble pencil

1 Paint a Base Background
Begin by choosing your two predominant colors for each panel. With your first color, brush on wide soft strokes of color mixed with soft body white to fill the background. The white will serve to soften the overall look of your background color.

2 Add Texture and Marks
Begin adding texture using any of the previously mentioned techniques (scraping, scratching, water droplets).

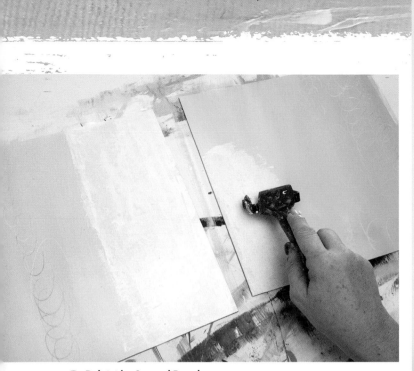

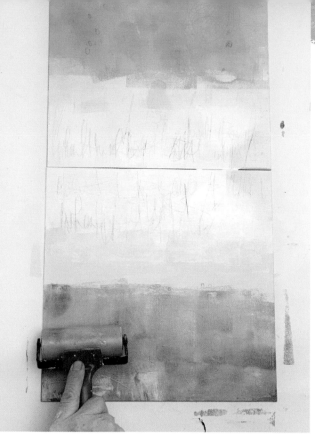

3 Paint the Second Panel

Repeat the process with your second color on the next panel. Fade out your colors by using a brayer. Roll paint onto the bottom (or right and left) of each surface to create a band of white.

4 Build Layers With the Brayer

Continue building up main colors by using a brayer rather than a brush to create interesting textures and uneven paint layers. Repeat as you see fit with more color.

At this point, audition the surfaces for your orientation of the two panels. You may decide that they fit together differently than you initially thought they would. Don't be afraid of changing the orientation.

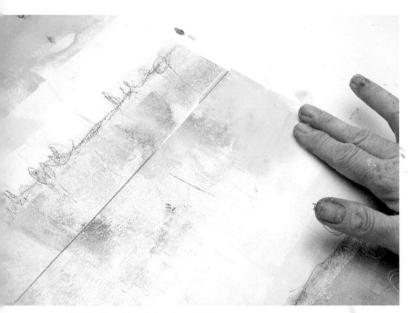

5 Define the Color Transition

Find a line that emerges between two color transitions and draw or write with the water-soluble pencil (or chalk pencil).

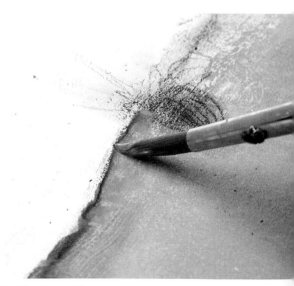

6 Paint Under the Drawn Line

Add a contrasting color of paint right underneath the drawn line, gliding the paint along the edge of it to activate the graphite for a shaded look. If you desire a sense of balance or continuity, repeat a similar step on the second panel. The trick to creating two pieces that tie together starts with the color used for both substrates, but the shapes, rhythm, movement and patterns you infuse between the pieces create cohesion.

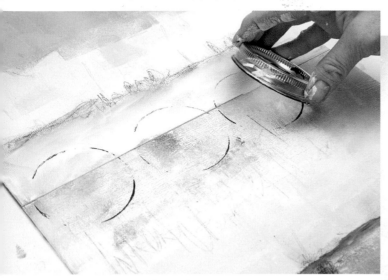

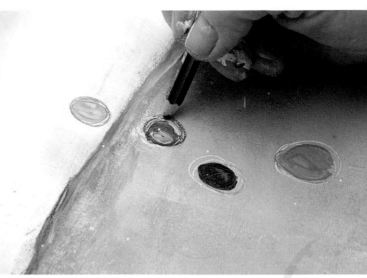

7 Stamp Onto Both Panels

Place the two surfaces close to one another and start adding patterns that connect the surfaces. In this example, you will see stamping of circles on the bottom and top of each panel using a lid rim painted in black.

8 Add Small Details

Now that the main colors have been blocked in, it's time to add details, patterns or marks. Change the values of your main colors by adding white, black or another mixture. This will increase the contrast in the work.

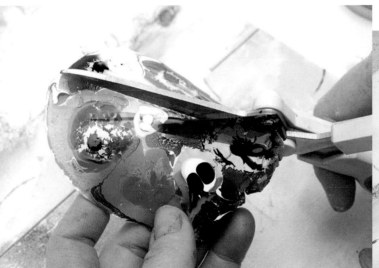

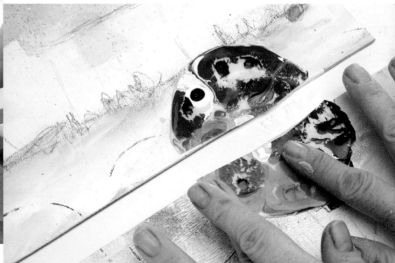

9 Cut the Acrylic Skin

Take the acrylic skin you made in an earlier project, and cut it into two pieces. Decide on a placement that will bind the two panels together.

10 Adhere the Acrylic Skin

Adhere the skin to the surface using soft gel medium. Gently push down on the skin, then smooth out the collaged pieces to ensure there are no air bubbles.

Keep Working No Matter How Long It Takes

Keep working with your surface until you're satisfied. Sometimes you may have to sit with a painting for a day or two. Sometimes you might not like the initial results. Change the orientation to see it from a variety of perspectives. It's not uncommon for an abstract to have ten, twenty, thirty or even fifty layers of paint before it's done!

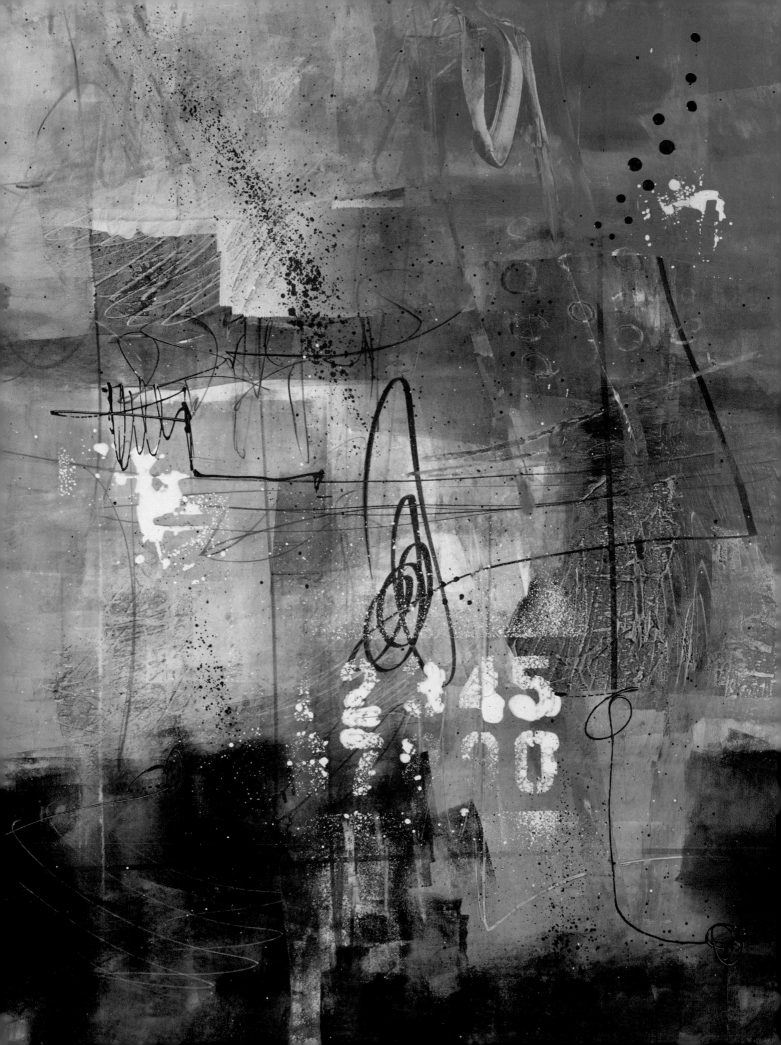

6 Experimenting With Inks and Acrylics

WORKING WITH YUPO PAPER offers so many possibilities to create beautiful and unusual watercolor-like marks. In the past, I used this substrate in my work mostly for watercolors and India ink, but once Golden formulated the Golden high flow paint, I knew that it would be exactly the right type of acrylic to use for even more intense designs, and I was right. In the next couple of examples, you'll see how you can create an "anything goes" type of edgy painting resembling a graffitied wall and another composition that is slightly more refined in design without losing the brilliant and colorful illusion of depth that's typical of Yupo paper designs. This is, of course, just the tip of the iceberg for what you can do. If you'd like to see more, be sure to check out my DVD from Artist's Network TV, *Graffiti Grunge Art,* or my full-length online workshop offered at Creative Workshops, Grunge Ink.

On Being Curious About Life and Exploring

"Twenty years from now you will be more disappointed by the things you didn't do than by the ones you did do. Sail away from the safe harbor. Catch the trade winds in your sails. Explore. Dream. Discover."

— MARK TWAIN.

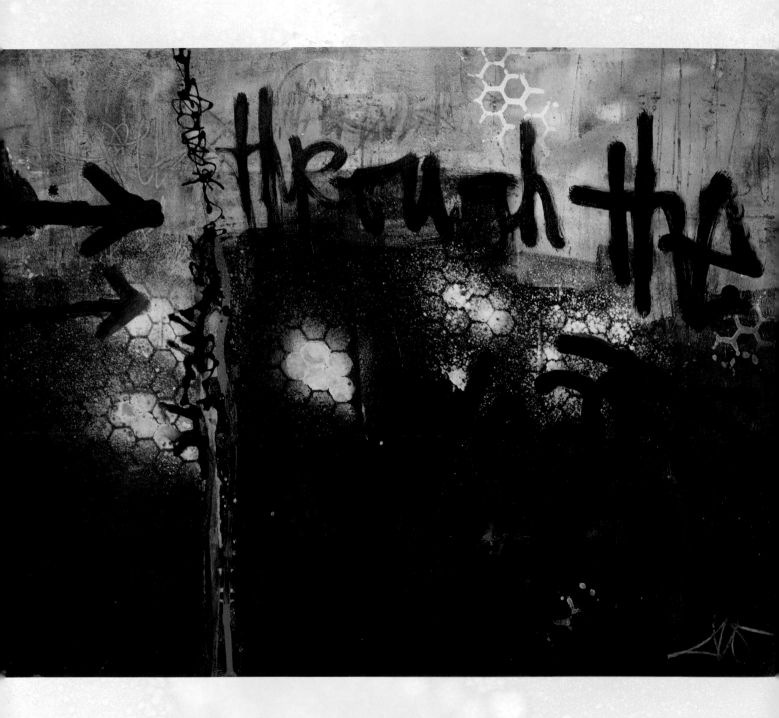

Graffiti Wall on Yupo

THIS IS YOUR CHANCE TO REALLY LET LOOSE AND EXPERIMENT. Your interpretation of what a graffiti wall is can go in many different directions. For me, painting on Yupo paper is the closest thing to attaining instant gratification that I've come across in all my years of painting. The process comes together so quickly. If you don't like something, no worries. Erase it with a damp cloth or baby wipe. Scrape into it, roll over it, drop ink and be ready to be amazed!

Materials list

22" × 30" (56cm × 76cm) sheet of Yupo paper

Assorted Golden high flow acrylics

Black India ink

Brayer

Fan brush

Fineline applicator

Golden dauber tips

Hair dryer

Neocolor II water-soluble crayons

Paper towel and baby wipes

Rubbing alcohol in a fine-tip applicator bottle

Scratching tools

Spray bottle

Stencils

Titanium White Golden fluid acrylic

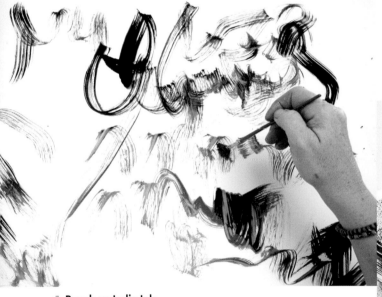

1 Brush on India Ink

Begin by taking a fan brush loaded with black India ink and make scribble marks all over the surface.

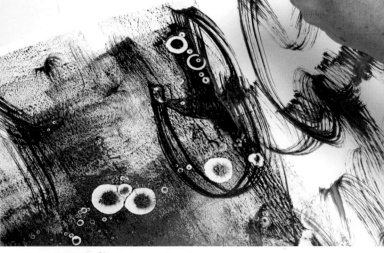

2 Drop Rubbing Alcohol Into the Ink

Use a brayer to roll solid areas of ink onto the surface. While the ink is still wet, drop rubbing alcohol onto the surface. This will create circular blooms as the ink evaporates outwardly from the alcohol drops. Play with dropping the alcohol from close up and further away from your substrate. Notice the variety of marks it makes.

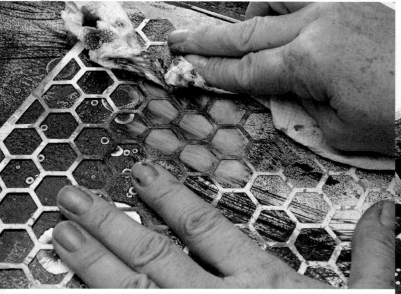

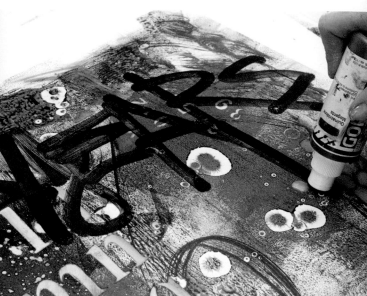

3 Pull the Ink With a Stencil

When the ink is dry, take a stencil and a soft, slightly damp cloth or baby wipe and subtract the positive areas of the stencil around various areas of your surface.

The ink will come off more readily if it is freshly applied. If you've waited a longer period of time, using a baby wipe will yield a more distinct result.

4 Write on the Surface

Place a dauber tip onto a small bottle of Golden high flow acrylic. Write your chosen words or phrases in a graffiti style on the surface. Use bold strokes and lines. You will repeat them throughout the painting.

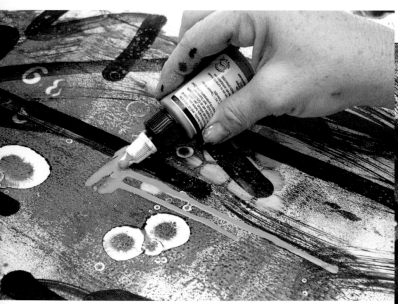

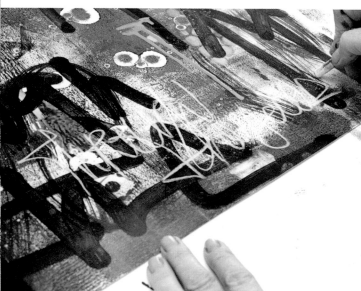

5 Add Drips of Paint

Create drips and runs of paint by dropping paint right from the Golden high flow bottle onto the surface. Tilt your painting so the pigment runs down.

6 Scribble and Write More

Write in various areas of your painting in a messy fashion. Your goal is to create some versions of your message that recede into the background layers and others that are more pronounced on the surface of your wall.

7 Add More Color

Add swatches of color using Golden high flow acrylics and a brayer at the bottom of the surface. Notice that because the crayon is water soluble, it will mimic a resist below the surface if you paint over it gently.

8 Continue Building Layers

Add paint and repeat dropping the alcohol onto the surface. If you remove too much paint as you build the layers, blow dry your surface at a low setting with a hair dryer. Because Yupo paper is plastic, do not use a heat gun; you'll risk melting or warping your surface.

9 Roll on New Layers of Color

Using a brayer, paint with Golden Titanium White fluid acrylic on the top. Try to envision an old worn wall that has been painted time and time again. Scratch into the top portion of your painting. Add another layer of color on the bottom portion.

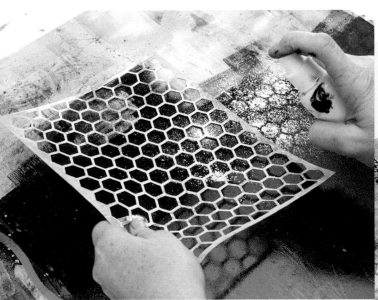

10 Spray Through a Stencil

Create your own "spray paint" by filling Golden high flow acrylic Titanium White into a small mister bottle. Spray a mist of paint through a stencil. Be sure to cover areas you want to protect from over-misting.

11 Final Details

Add final touches by using a Fineline applicator and dauber bottle. Repeat your word or phrase with each. Splatter paint in a contrasting color to tie the work together.

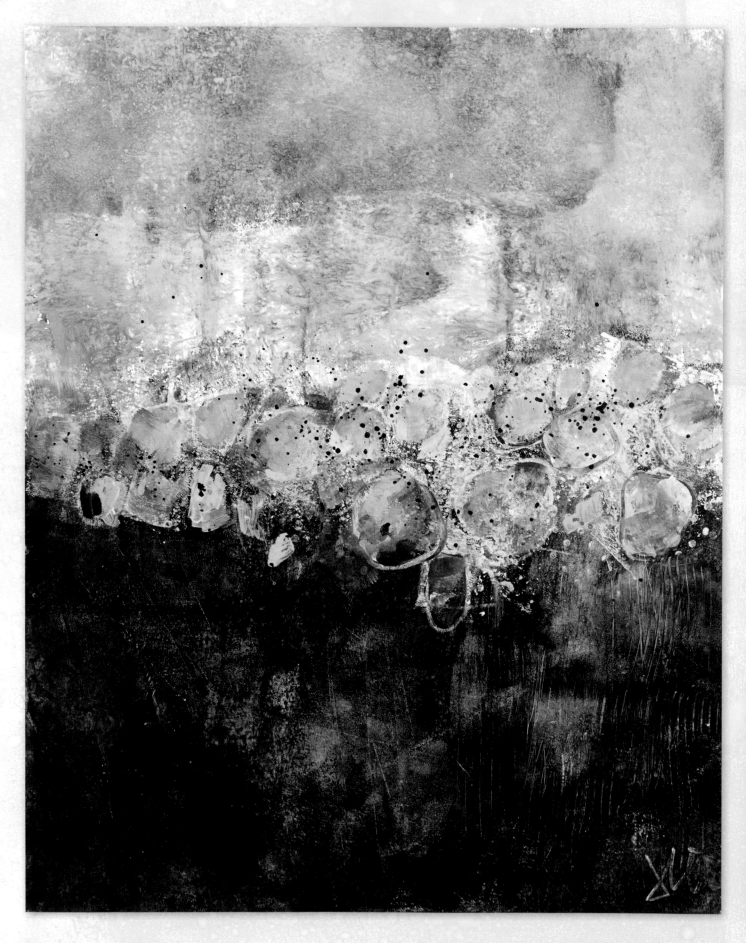

Rust Colored Landscape

DRAWING ON THE INSPIRATION OF SOME OF YOUR NATURE PHOTOS and the technical skills you learned earlier, this exercise calls for a slightly more refined composition. You will want the viewers to feel like they are walking up on a pile of rocks or perhaps just about to look over a rock wall and into a magical garden just beyond. The magic of Yupo will shine through even though you rein in the looseness to create a more representational abstract work. Let's explore this amazing surface once again.

Materials list

Baby wipes

Black India ink

Cosmetic sponge

Golden high flow acrylics: Permanent Violet Dark, Quinacridone/Nickel Azo Gold, Teal, Titanium White

Hard brayer

Neocolor II water-soluble crayon

Paper towels

Rubbing alcohol (mister bottle and an applicator bottle)

Soft foam brayer

Water-soluble pencil (optional)

Yupo paper

1 Spread India Ink on Your Surface
Brush India ink across the horizon line of your surface. Spread the ink using a hard brayer, which will garner a more uneven spreading of ink while a soft brayer will mute the ink and soften the edges. Using a hard brayer for this step will allow for the more pronounced texture you need at this stage.

2 Spread the Excess Ink
While the ink is still wet, apply excess ink above the horizon line with the brayer to achieve a slightly shaded look from the residual ink.

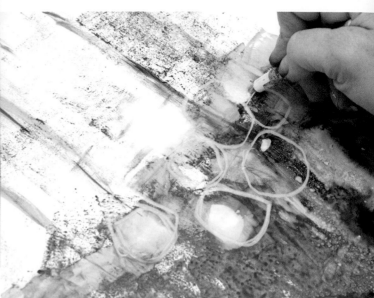

3 Spray Rubbing Alcohol
Distress the India ink by spraying rubbing alcohol in a mister bottle onto the semiwet surface. You'll see small granular marks appear as the ink moves away from the rubbing alcohol.

4 Draw Rocks
In the area of your horizon line, draw in rock shapes with a Neocolor II crayon.

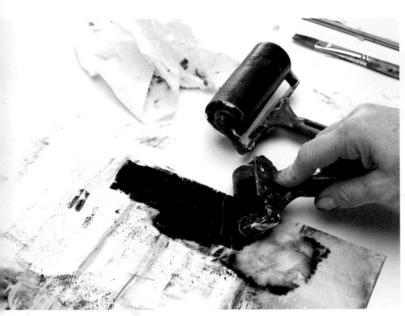

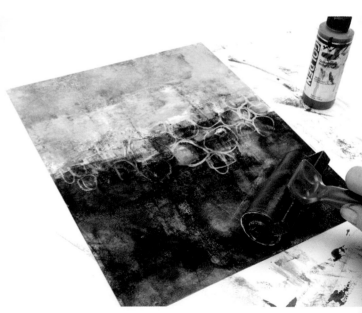

5 Add Texture
Add texture both above and below the horizon line of the painting. Go back and forth between using both the hard and soft brayers and spraying rubbing alcohol to soften the ink. You can also use a paper towel to pull up the color or to blend in edges.

6 Roll on Additional Colors
Clean your brayers with a baby wipe before moving on. Start bringing in additional paint colors at this point. Use Titanium White on the top of your horizon line and Quinacridone/Nickel Azo Gold below.

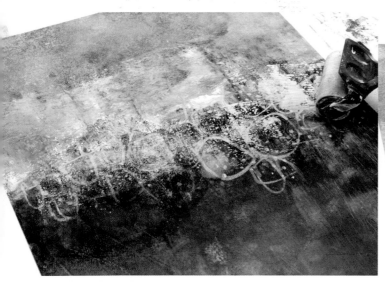

7 Add a Pop of Color

Use Teal fluid paint and a soft brayer to cover up some of the rocks at the horizon line. You can redraw the rock shapes afterward.

8 Define the Rock Shapes

Use a paintbrush to paint the rock shapes with Teal, white and lavender. Mixing Permanent Violet Dark and Titanium White makes a great lavender. This fresh color will add dimension and light to your rock shapes. Fill in some of the gaps between the rocks with Quinacridone/Nickel Azo Gold. Let dry.

9 Add Paint Splatters

Add splatters using all of your composition's paint colors. It's okay if some splatters fall beyond the rock. Repeat these last few steps to build up the depth of the rocks. You can also add a bit of shading with a water-soluble pencil, if you like.

10 Final Details

Finalize your piece by adding another layer of the Quinacridone/Nickel Azo Gold to the bottom. This creates a rich, rusty color for your landscape.

Words of Wisdom

Don't be afraid to try strange color combinations. Tiptoeing between the world of reality and the world of abstraction is freeing if you get out of your head and give it a chance on the canvas.

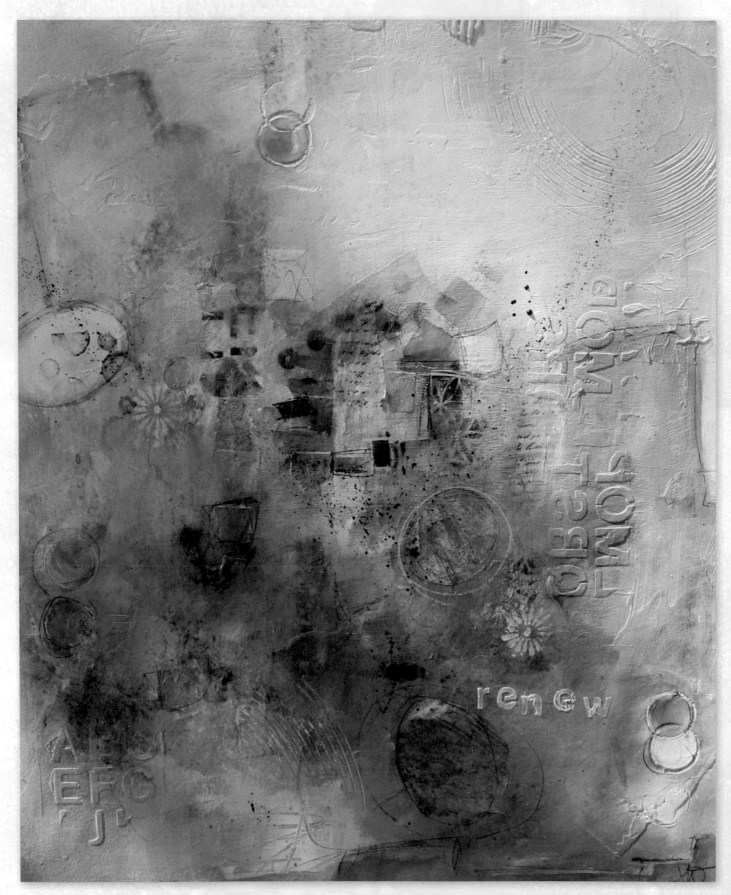

▲ RENEW
20" × 24" (51cm × 61cm), acrylic, modeling paste, texture
tools, NeoColor II water-soluble crayons on canvas

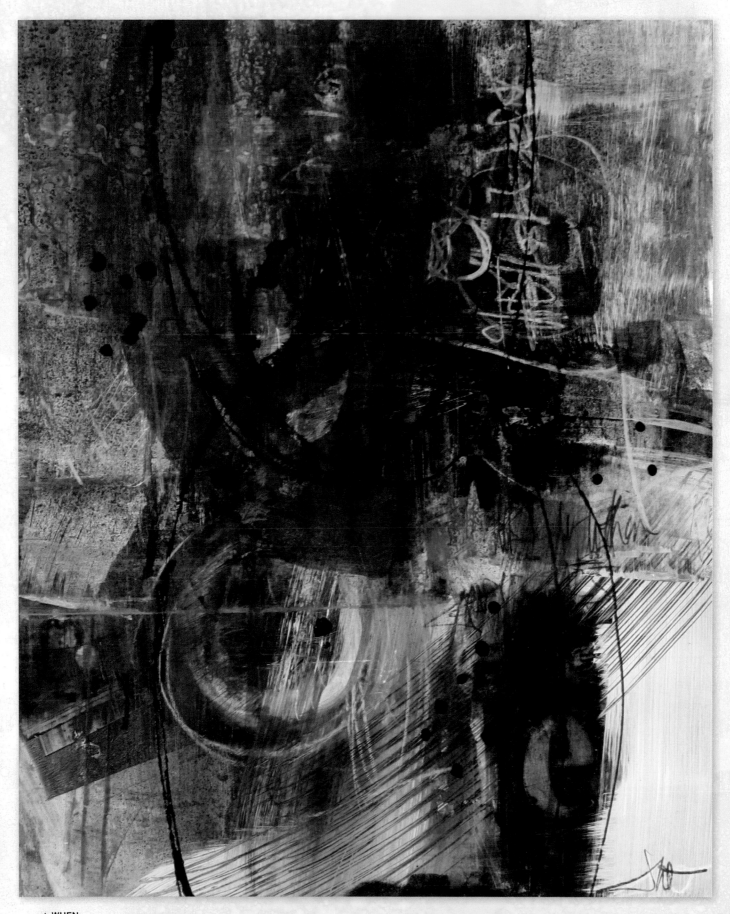

▲ **WHEN**
11" × 14" (28cm × 36cm), acrylic ink, acrylic
paint, pen, chalk, scraping tools on Yupo paper

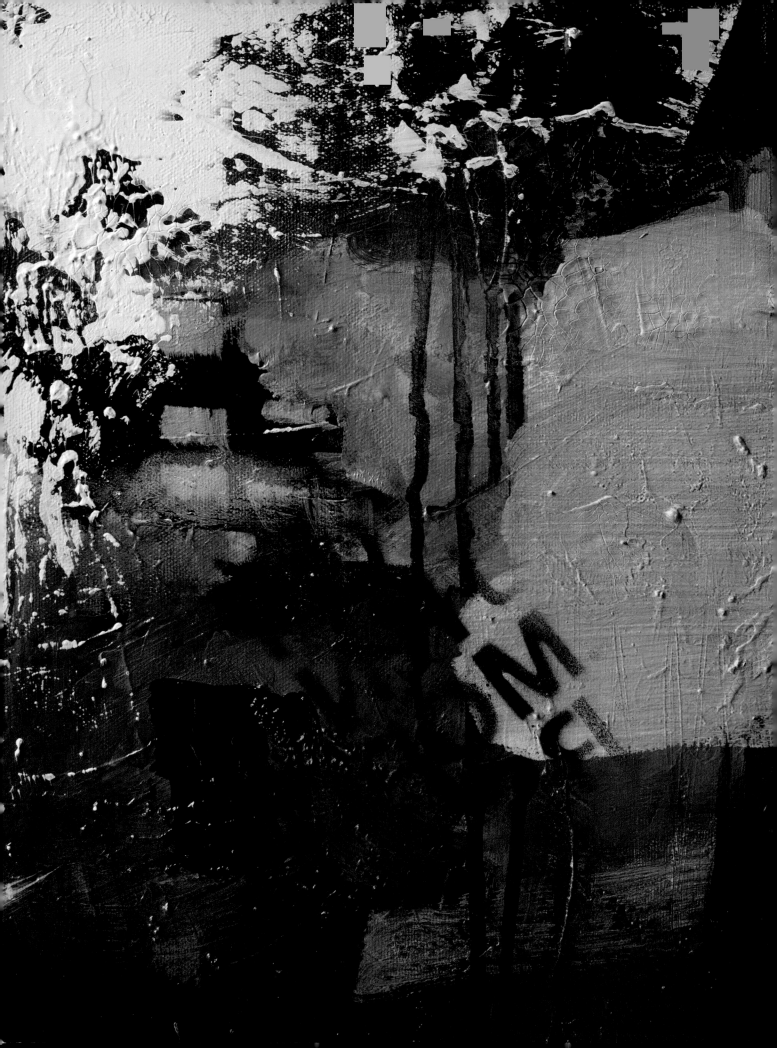

7 Abstract Collage

WHEN I FIRST STARTED DABBLING in mixed-media art, collage was one of my favorite genres to create in. Something about getting lost in a pile of papers I collected or created during a printing session just did it for me. As I leafed through sheet after sheet and remnant after remnant, I found it easy to get swept up in the moment and forget any troubling thought. I was searching for the right way to say what was on my mind but didn't quite know how to express myself, and collage showed me the way. My first few art pieces were admittedly disjointed and not great compositions. Nevertheless, I took great joy in pasting paper after paper together and later peeling the layer of glue from my fingers. That sense of satisfaction is perhaps even more elevated as we flash forward a few years later because I no longer rely solely on papers that other people have made or cut-outs I've saved from magazines. Most of the papers I use in my collage nowadays are from deliriously fun printing and painting sessions or from collections I've more judiciously selected based on texture or patterns I'm drawn to in that moment. Let's take a moment to explore a few ways to incorporate collage elements in your work.

On Not Giving Up

"I shall become a master in this art only after a great deal of practice."

— ERICH FROMM

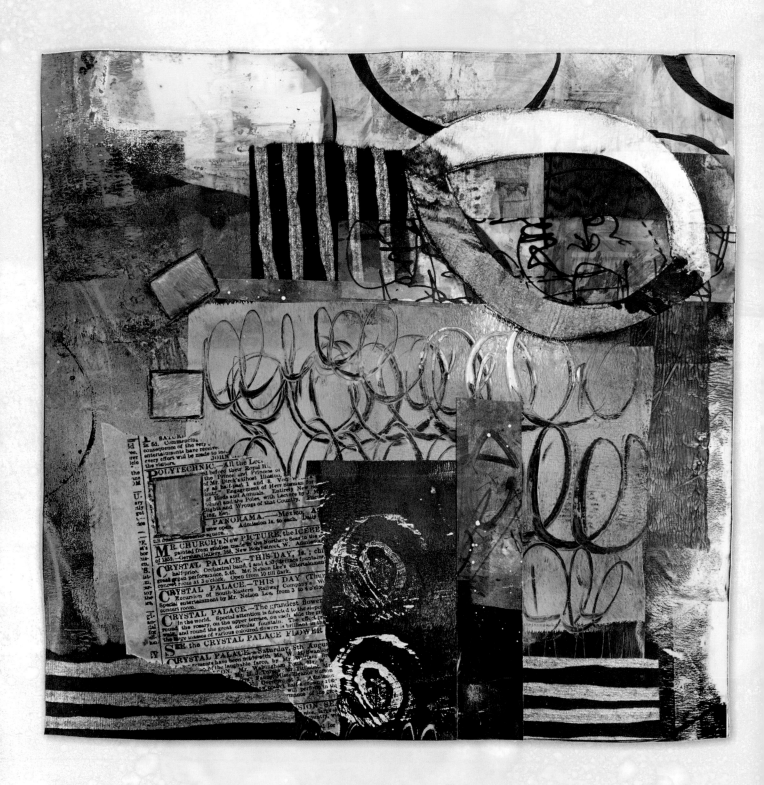

Demonstration

Grid Collage

GRAB THOSE PAPERS YOU CREATED; it's time to use the fruits of your labor in this next grid form. Instead of painting a grid or using a brayer to create the illusion of layers, we are going to take all the prints you've made, along with any other papers you've collected, and fuse them together in a fun, contemporary collage. If you are at a loss as to where to start, spread your papers out and see which pieces speak to you first. You'd be surprised how one or two colors or patterns can spark an idea you can use for the entire piece.

Materials list

Assorted papers

Brayer

Charcoal pencil or pen

Craft knife

Deli paper

Matte gel medium

Phone camera

Scissors

Scraping tools

Stamps and stencils

StazOn ink pad in black

Watercolor paper

Wood board

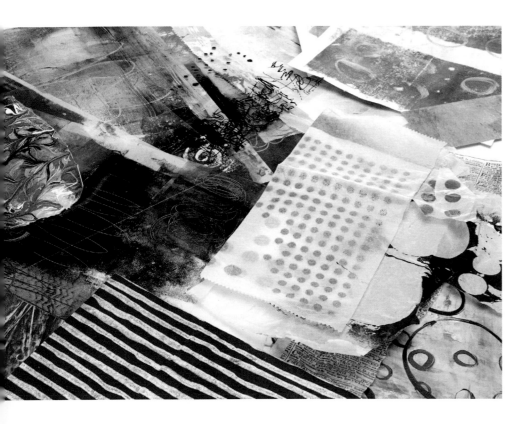

1 Gather and Choose Your Collage Papers

Spread out an assortment of papers. You can use papers painted and printed in earlier chapters or ones you've created on your own. Feel free to add interesting papers you've collected commercially, too. You also want a mixture of papers that have solid areas in addition to patterns and text. Tissue or deli paper also make great choices for a layering effect.

I find it best to organize my papers by color and then by paper type so when I go to grab a collage element the pieces are fairly organized.

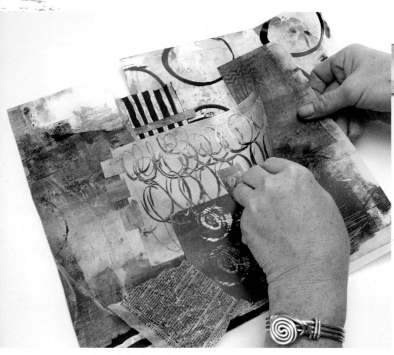

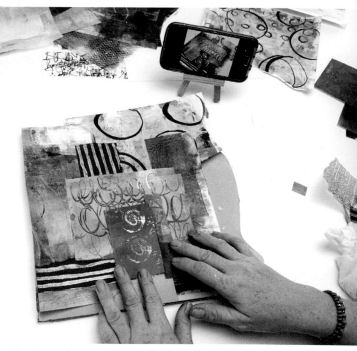

2 Play With the Collage Arrangement
On a piece of watercolor paper cut to size, begin arranging your collage elements. Alternate between cutting and tearing papers to create a varied look. Position some pieces under one another and continue working until you are satisfied with your placement. You are only auditioning your pieces at this point, not adhering them to the paper.

3 Take a Picture Before Adhering the Paper
Once you have your placement set, take a picture of your collage with a camera phone. This will help you remember how each piece fit before you take it apart and then reconstruct it with the final adhesive. Using your picture as a guide, glue your papers onto the surface using matte gel medium. Ensure your papers are adhered from edge to edge and that all air bubbles are removed. Using a brayer or scraping tool is a good way to achieve a good bond. Refer to your photo as needed to rebuild your collage.

4 Trim the Collage
Once your collage is finished, allow it to dry. If it feels cool to the touch, your piece needs more drying time. Turn the collage over and trim the excess with a craft knife.

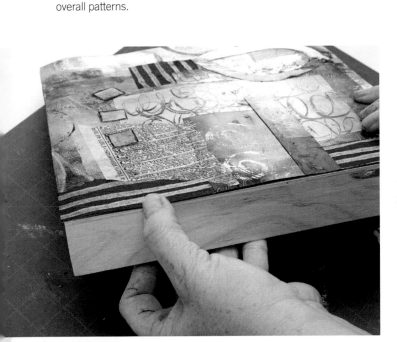

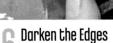

5 Add Doodles
Add extra doodles and shading with a charcoal pencil, pen or additional stamps and stencils to enhance the dimension and overall patterns.

6 Darken the Edges
Rub a black StazOn ink pad on the edges of your collage to give it a polished look.

Other Options

You can frame your collage rather than adhering it to a board. You may want to scan your finished piece so you can recycle your design into future artworks. Simply print out a laser copy to use multiple times in various creative ways.

7 Adhere to a Wood Board
To finish your collage, adhere the piece to a wood board. Use a gel medium rather than a fluid medium to lessen the risk of bubbles. Spread medium on both the board and the final collage prior to positioning. Take a piece of drawing paper or deli paper, and place it over the top of your collage. Then roll your brayer starting in the center and working your way out over top of the paper. Check for bubbles and make certain the edges are securely adhered to the board. Place a clean sheet of deli paper on top of your finished piece and add a heavy book to the top for extra weight. Let dry overnight. Check the collage for any loose edges and repeat if needed.

Demonstration

Abstract Macro Picture Collage

HAVE YOU EVER LOOKED THROUGH YOUR PHOTOS and noticed that a small part of a particular photo would make for an interesting composition if it was enlarged? Taking macro shots (an extreme close-up shot) or enlarging a photograph often yields a unique perspective. In one of my travels to the beach I came across a nest of buoys hanging from a tree. Perhaps they were left over from a fisherman's trip out to sea. The group would definitely make a great photo or painting, but there was something about the texture of the buoys that intrigued me. Perhaps it was the cracks and marks, I'm not sure. For this example, try using one of your photos enlarged to highlight only a portion of the overall picture. Then you will incorporate gel mediums or textural mediums to enhance what you are trying to convey in your collage.

Materials list

6" × 6" (15cm × 15cm) wood substrate

Assorted acrylic paints: Napthol Red, Green Gold, Quinacridone/ Nickel Azo Gold, Titanium White, Carbon Black

Black gesso

Brayer

Brush

Clear crackle medium

Collage papers that coordinate with your macro picture

Glass beads

Glazing medium

Laser copy of a macro picture (Choose something that has an interesting textural component)

Matte gel medium

Palette knife

Paper towel

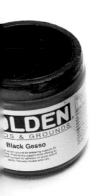

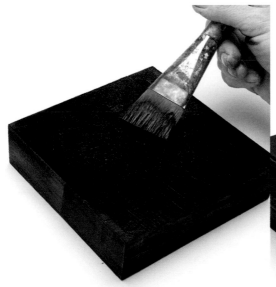

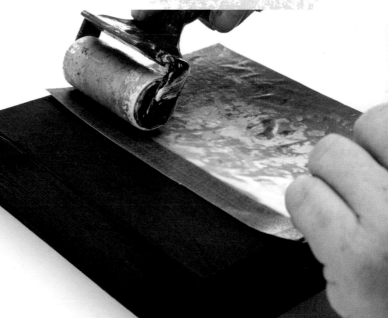

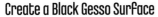

1 Create a Black Gesso Surface
Prep your surface with black gesso. Allow it to dry.

2 Adhere the Photo
Take a laser copy of a photograph that has been blown up or taken on a macro level so that the details are enlarged. Adhere the image to a portion of your surface using gel medium. Roll your brayer over the top to bond the photocopy to the substrate.

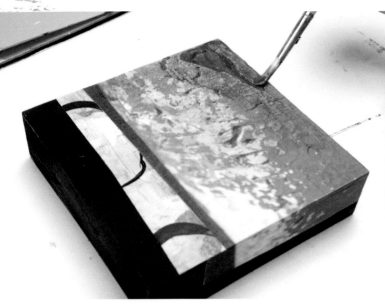

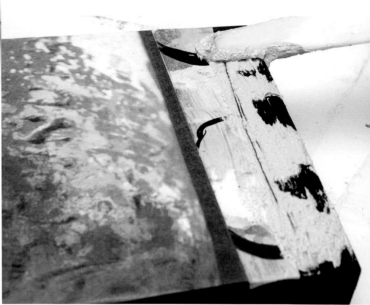

3 Enhance the Collage With Paint

Add any collage elements you find interesting. Here a paper painted in an earlier chapter was used. Once the papers are dry, you can enhance the photo's appearance by painting it with a color that coordinates with the paper. In this instance I created a glaze using Napthol Red and glazing medium, and brushed it over the right side of the buoy to add more saturation to the picture. Use whatever color matches closely in your collaged photograph copy.

4 Add a Glass Beads Mixture

Mix paint into a dollop of glass beads. Green Gold was added to the clear glass bead texture mixture since it is the complement of red, and they naturally go well together. Add the mixture to the left of your collage elements using a palette knife.

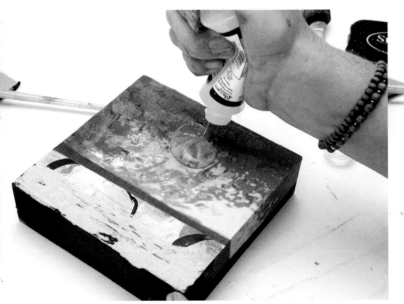

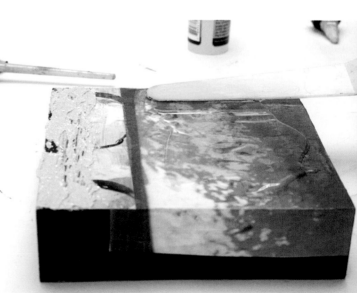

5 Add Clear Crackle Gel

Add a layer of clear crackle gel medium over the photograph. Double-check that you are using clear crackle medium and not crackle paste. The clear medium will dry transparent and the paste will dry opaque. Allow it to dry approximately twenty-four hours, depending on your climate. More humidity will require more drying time.

6 Spread the Gel

Spread the crackle gel evenly with a palette knife into any area you would like to enhance with a cracked surface.

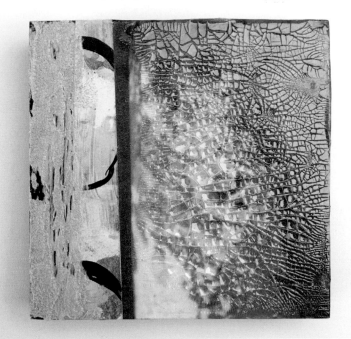

7 Enhance the Crackles With White

Once completely dry, add a touch of white paint over the top of the crackles. This will add to the mystery of your unique, textured collage.

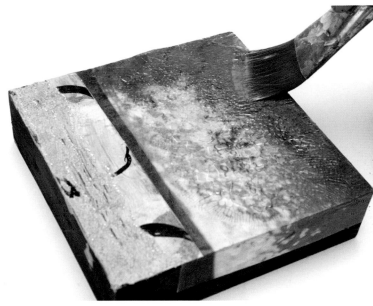

8 Add Warm Tones

Warm up the top layer by brushing on Quinacridone/Nickel Azo Gold over select areas.

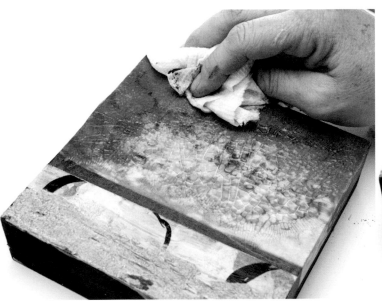

9 Remove Excess Paint

Push back some of the paint by wiping gently with a paper towel immediately after you've painted with the Quinacridone/Nickel Azo Gold.

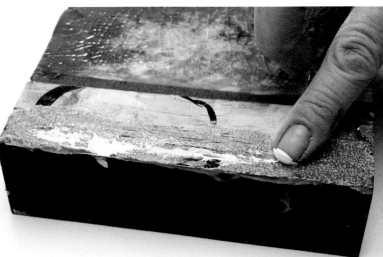

10 Final Details

If you like, add a touch of Titanium White to a few select areas. When you're done, touch up the sides using carbon black acrylic paint.

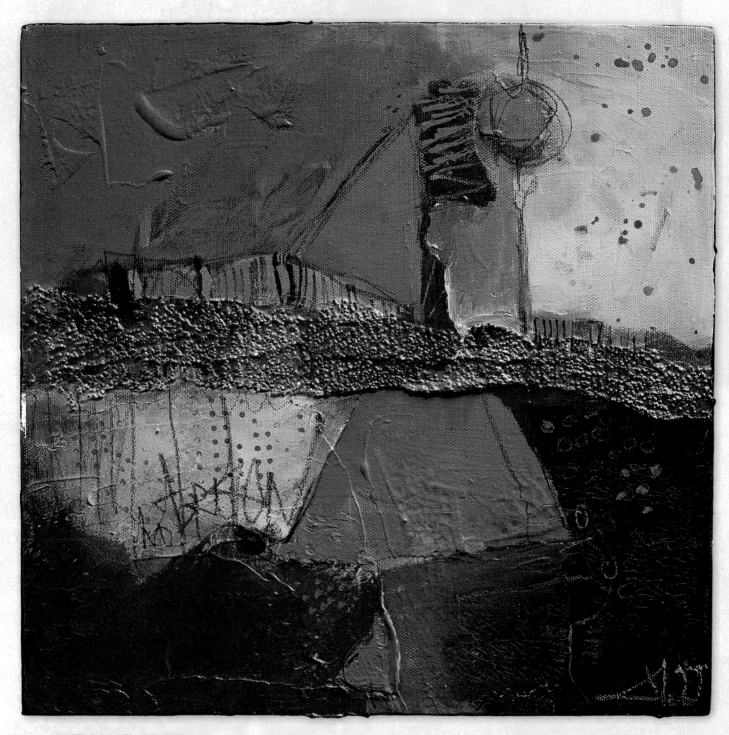

▲ **SHATTERED BUT NOT BROKEN**
12" × 12" (30cm × 30cm), acrylic, glass beads,
modeling paste, Stabilo pencil on canvas

▶ **THE LOOKING GLASS**
11" × 14" (28cm × 36cm), acrylic paint, crackle
medium, glass beads, collage on MDF board

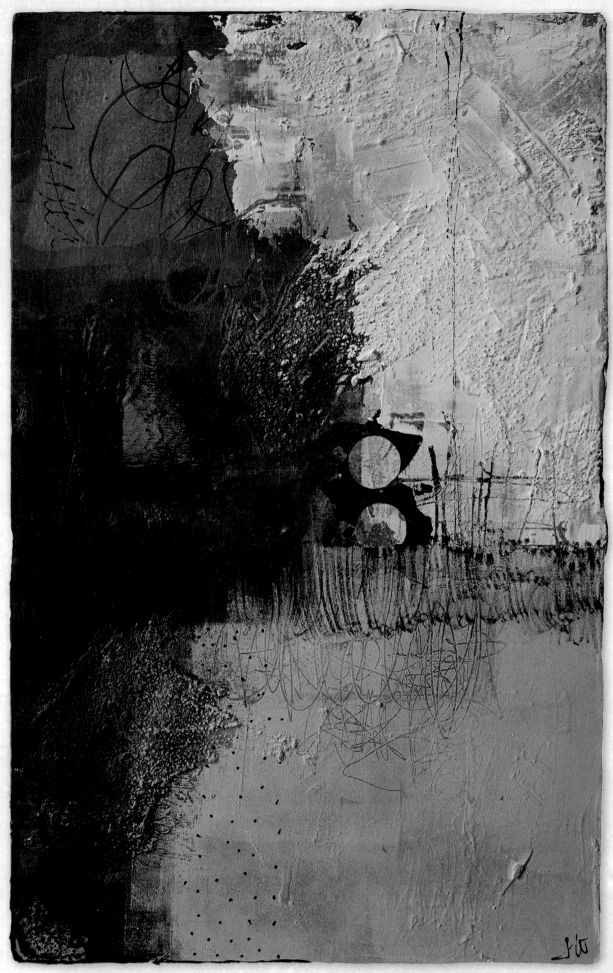

125

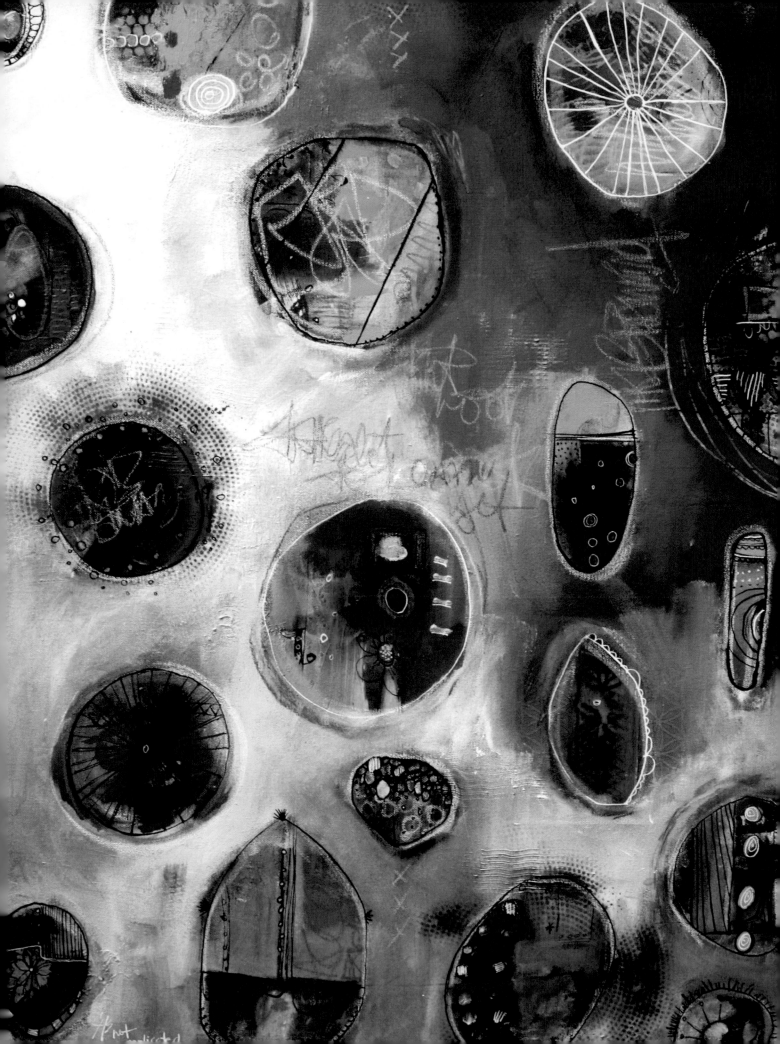

8

Finishing Options and Contributors

◄ **IT'S NOT COMPLICATED**
24" × 36" (61cm × 91cm),
acrylic paint, ink, chalk,
Neocolor II water-soluable
crayons on canvas

ONE OF THE NUMBER ONE QUESTIONS I am asked when teaching workshops is how to finish one's artwork. How to protect your art against the elements and harmful UV rays is an important consideration. Those final touches you put on your art can also elevate your pieces, giving the composition a polished, professional look. Sometimes a particular work will call for a certain finish that only you as the artist will know how to answer. Where one work may look smashing with a gloss finish, the shiny glare may be overkill on another. In the next few samples we will showcase options beyond the traditional framing and discuss the differences between some of the choices available to you, the artist.

On Being a Visionary
"The visionary starts with a clean sheet of paper, and re-imagines the world."
— MALCOLM GLADWELL

Varnishing and Finishes

TO VARNISH OR NOT TO VARNISH, that is the question. For me, I almost always use a spray varnish in matte to finish my pieces. Because I use many drawing mediums in my work, such as water-soluble crayons, charcoal, chalk and water-soluble pencils, the spray varnish will fix those mediums so they do not smear or accidently activate if moisture is dropped on the canvas. I will use a gloss spray varnish when a piece of art calls for a brighter, shiny finish. Most spray varnishes come in matte, satin or gloss. Use whichever sheen is most pleasing to you or what you feel the art calls for.

In addition to spray varnish, I also use a matte or satin liquid varnish on many of my larger pieces. In the sample below you will see how first I use the spray and then the liquid after the spray varnish has dried. If you use a lot of drawing mediums or ink in your work, you need to create an isolation layer by using the spray varnish prior to using the brush-on liquid varnish. Besides protecting my work from the elements, I find varnishing also enhances the color and enriches a work of art. Personally, I feel varnishing your work adds a professional look to the completed piece.

Materials list

Assorted large flat brushes

Brayer

Craft knife

Deli paper

Fineline applicator filled with fluid paint

Golden's archival spray varnish in matte or gloss

Hardbord or wood block surface

Liquitex satin or matte varnish

Matte medium

Metal ruler

Palette knife

Pouring medium

Spray adhesive

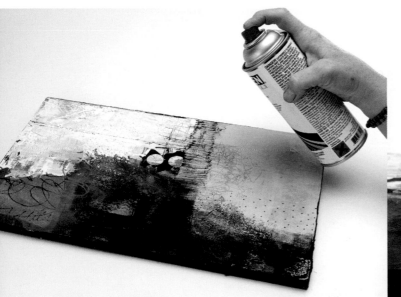

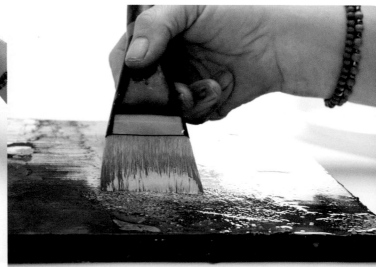

Apply a Spray Varnish

First, ensure that your work is thoroughly dry before applying any sort of varnish. Whenever you've used drawing mediums on your piece, it is recommended you use one to two coats of spray varnish to create a barrier layer before using a brush-on varnish as the drawn marks could smear when applying the brush-on varnish. Apply it according to the manufacturer's directions. Typically I like to wait several hours, if not a day or so, before applying the second layer. This lessens the risk of elements blending or varnished areas being uneven.

Apply a Brush-On Varnish

A brush-on varnish often will enhance your colors and provide long-term protection for your work. While most professional varnishes come in different sheens (matte, satin, gloss), you may find a combination of any of the above to be the perfect mixture for your own work. Layer your varnish in one direction (horizontally or vertically). Allow it to dry. Repeat, brushing in the opposite direction. Work under a good light source so you don't miss an area.

Tip: Take photographs of your work prior to adding a glossy layer. While enhancing the work in person, the glare from the gloss makes it challenging to photograph well.

Mounting Your Piece On a Board

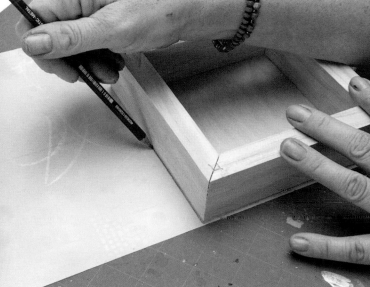

1 Save Sections of Paper
There will be times when you create painted papers or printed papers that you are unhappy with overall. Instead of throwing out those pages, view them with a viewfinder or an open matte board to see if you can isolate a gem of an area in your composition. Cut out and use that section to collage onto a Hardbord or wood block surface.

2 Trim the Paper
Once you find the spot of the paper you want to save, mark it and trim it down using a craft knife and a metal ruler.

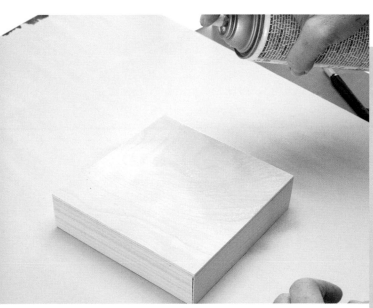

3 Spray the Adhesive on the Surface
In a well-ventilated room, use spray adhesive to adhere your paper to the surface. Be sure to move anything that might be affected by the overspray of the adhesive.

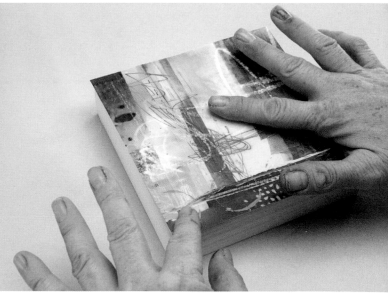

4 Adhere the Paper to the Board
Use your fingers to flatten any bubbles and to slide your design onto the board.

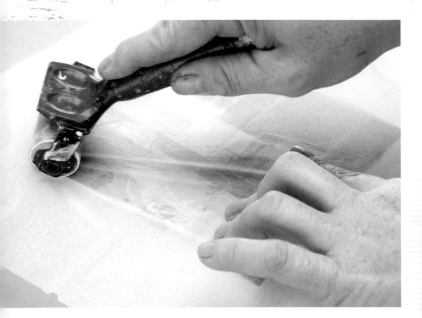

5 Smooth the Paper

Place a piece of deli paper over your collage and roll the brayer over it to adhere the glue and paper to the surface. Spray adhesive can be tricky to use, as it is extremely sticky. Take care not to move the paper too much. Place a weight over the collage or painted paper.

Trim any excess paper after it has completely dried. Your once less-than-desirable full painted paper/collage is now cropped down into your favorite area of the composition.

Keep Multiple Cut Sections of Paper

If you have a large piece of painted or printed paper, consider cutting it up into multiple pieces. Use a variety of board sizes (6" × 6" [15cm × 15cm], 8" × 8" [20cm × 20cm], 10" × 10" [25cm × 25cm]) to make an interesting display of your collection.

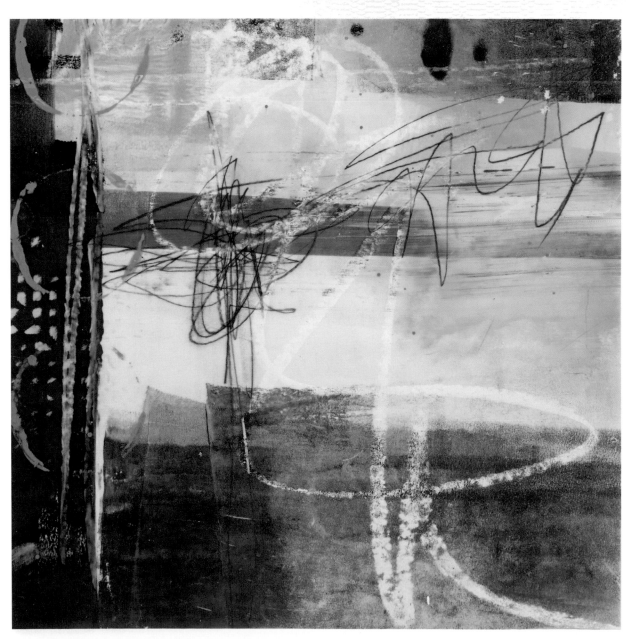

Finishing With Pouring Medium

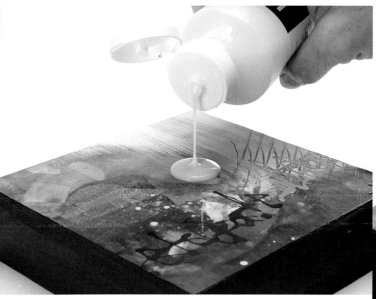

1 Add Pouring Medium to the Center
Add pouring medium over the top of your dried composition. Start pouring the medium in the center and let it spread naturally.

2 Spread the Pouring Medium
Take a large spatula-style palette knife and smooth out the pouring medium until it is evenly applied over the entire piece.

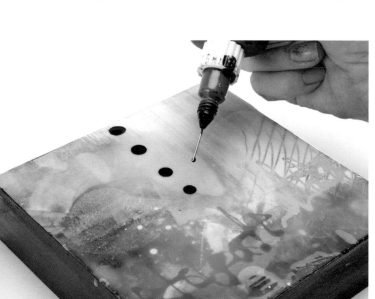

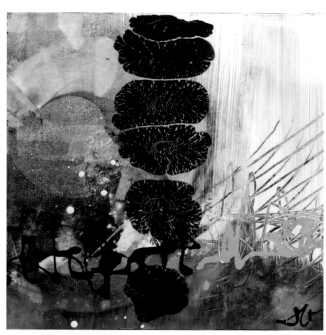

3 Drop Paint Into the Medium
Another way to add dimension is to use a Fineline applicator to drop paint into the pouring medium. The more fluid your acrylic paint is, the more it will bloom into the pouring medium.

4 Let the Piece Dry
Allow the piece to dry at least twenty-four hours before you handle it. Depending on your area's climate and humidity, drying could take several days. The result is faux resin, or a glasslike topcoat. The paint colors underneath will be enhanced as well.

Final Words

AS THIS PLAYFUL PAINTING WORKSHOP comes to a close, I hope your mind is reeling with ideas for creating beautifully layered and textured abstracts. Venture in fearlessly! Try new materials, substrates and colors as you use these techniques in your work. I thank you for taking the time to immerse yourself in this workshop, and I look forward to our paths crossing down the road.

Before I leave you, though, I want to share some abstract art from some of my talented friends. I've had a few of these lovely souls in my classes; others I have met through art retreats or online. Many are also teachers who share my love of spreading creative inspiration to eager students around the world. I chose each of these artists because their work captures many of the aspects of color, pattern, texture, value and contrast that we've discussed throughout the book. Read on and enjoy the gallery of wonderful contributors.

Deborah Belica

DEBORAH BELICA'S use of bold colors and distinctive textures in her mysterious and delightful mixed media and acrylic abstracts leave the viewer with a sense of wonder and curiosity. Deborah has a diverse background in the arts—owning pottery shops, writing children's books and taking photographs—she has turned her creative talents to the canvas. Deborah's art showcases an appreciation for the positive side of life through color and composition.

"For me art is a creative form of expression for the thoughts and emotions of my mind and heart," says Deborah. "Colors make me happy, and I feel inspired exploring the connection of art and viewer."

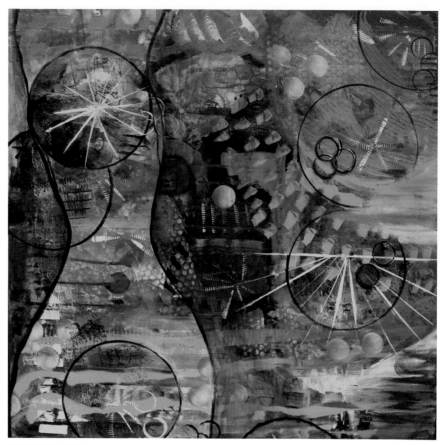

CIRCLES OF LIFE
24" × 24" (61cm × 61cm), acrylic and oil pastels

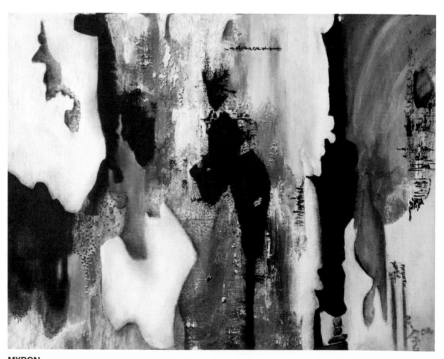

MYRON
16" × 20" (41cm × 51cm), acrylic, oil pastels and ink

Amy Smith

AMY SMITH is a primarily self-taught contemporary artist working in paint, collage and other media. Her work is richly layered and vibrantly colored, and invites the viewer to go a bit deeper.

"Abstract painting is a vehicle to outwardly express the deep inner work of the Spirit in me," Amy says. "When I begin to work on a piece I do not usually have a finished work in my mind. I may have a shred of an idea to start from, but I never have a plan. I am inspired by emotions, relationships, current events, the natural environment and most centrally, my faith in relationship to all of these things. I work intuitively, moving among my paints, charcoal and collage papers as the piece develops and tells me where it wants to go. I am not sure that my pieces are ever really finished, but they come to a resting place that seems to make sense within the framework of the story being told. Like my own story, there is always another chapter to move on to, but each piece of art captures one moment in time."

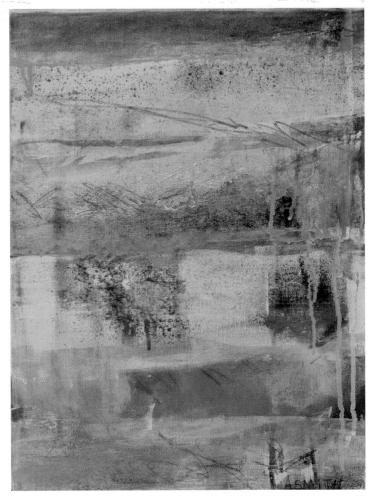

WAITING FOR SUMMER
12" × 16" (30cm × 41cm), acrylic, graphite and collage

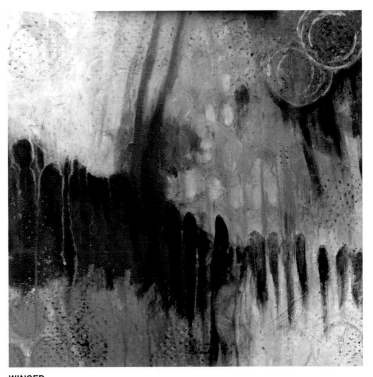

WINGED
20" × 20" (51cm × 51cm), layers of acrylic paints brushed, scraped and dripped

Patti Tolley Parrish

PATTI TOLLEY PARRISH is a mixed-media artist who loves to try everything and experiment with new products and tools. She designs her own line of stencils for iStencils.com and matching rubber stamps that she sells on her Etsy shop, Inky Obsessions. Her stamps and stencil designs reflect her love of geometric and abstract art. She does art demos on her YouTube channel and live broadcasts on Ustream.tv. Patti lives in Severn, Maryland, with her husband, Dave, and their studio pups Mojo and Babe. Find more at http://inkyobsessions.blogspot.com/

"I've always been attracted to water—salt or fresh, still or moving, ocean, bay, rivers, pools, even in my tub," says Patti. "I was raised on the Chesapeake Bay and spent decades offshore in the Atlantic Ocean scuba diving and fishing in the Gulf Stream. I'm the most happy and relaxed when I'm near the ocean and can hear the action of the waves on the beach and smell the briny salt air. I love how you feel almost weightless and fluid when you are in the water. This feeling of fluidity is what inspired this design. It was a very messy process creating this piece, but the kind of mess I love. I usually paint the edges of my canvases with either black or white to finish off the piece, but the inky mess that dripped off the bottom of the canvas was too pretty to cover up. This dripping ink is what inspired the name OverFlow to this series of my work."

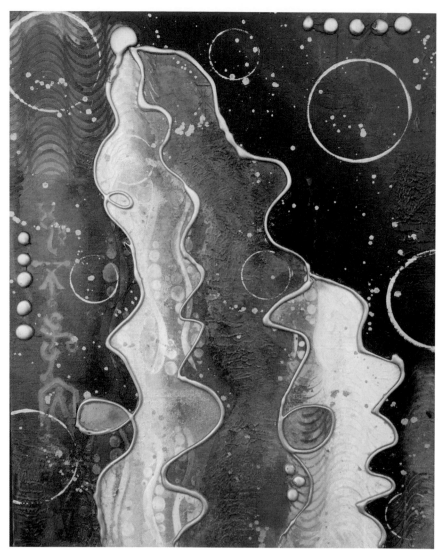

OVERFLOW
16" × 20" (41cm × 51cm), acrylic inks, hot glue, molding paste, starburst sprays and metallic wax pigment

Nathalie Kalbach

NATHALIE KALBACH is a self-taught mixed-media artist. She worked as a paralegal for seventeen years and might have remained in the wrong profession had she not discovered mixed-media painting in 2004.

Nathalie has spent the last decade exploring the possibilities of creating dimension and texture by layering different materials and paint. She has worked in art journals and on canvases, incorporating collage and found objects. Her projects have been published in craft and hobby magazines as well as mixed-media books. She has taught at many retail events, art retreats and trade shows. By 2011, she was able to give up working as a paralegal to become a full-time artist.

"For me, creating art is a dialogue between my skills and the supplies I use," Nathalie says. "It is not so much a battle as an ongoing attempt to work out the connections between ideas and techniques. In my mixed-media canvases I emphasize urban subject matter, especially gentrification. From multiple viewpoints, I depict the vibrancy as well as the decay that I see in the cities around me, represented by layering and tactile dimension.

"I believe that everyone can be creative. Since 2006, I have taught workshops around the world. I share what I know about tools, supplies and techniques, with the goal of helping each student unlock his or her personal creativity."

STANDING STRONG
16" × 12" (41cm × 30cm), acrylics, spray paints, markers

ON THE FLIP SIDE
16" × 16" (41cm × 41cm), acrylics, inks, markers and spray paints

137

Mary Beth Shaw

MARY BETH SHAW worked in the insurance industry for eighteen years before she quit her job in 2000 to re-ignite a childhood love of art. She is now a full-time painter and internationally known workshop instructor. Her creative process is largely self-taught, spontaneous and joyful. She is author of *Flavor for Mixed Media* and *Stencil Girl*, both published by F+W Media Inc., and she is also a columnist for *Somerset Studio* magazine.

In 2010, Mary Beth recognized a need for artist-designed stencils and created StencilGirl Products, which has quickly grown into a respected supplier of high-quality stencils for all media. Living with her husband and three cats, Mary Beth is passionate about every moment of life.

"My painting process is a dance between spontaneity and intent," Mary Beth says. "I start out with raw marks, random color and texture, then move into defining the composition and ramping up value changes, often moving backward and forward numerous times until I am satisfied. Although harrowing in the moment, I ultimately believe that mistakes and ugly stages are simply a message that I am not finished yet; they propel me forward into new territory. I find great joy in the physical act of painting and creating layer upon layer of depth."

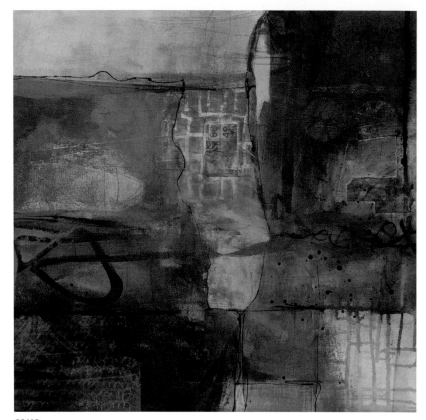

60/49
24" × 24" (61cm × 61cm), acrylic, collage, ink, marker, pencil

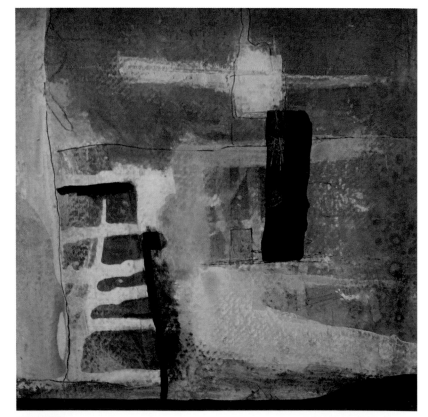

THE EDGE
8" × 8" (20cm × 20cm), acrylic, pencil, marker

Ardith Goodwin

ARDITH GOODWIN combines her love of writing and educating with a self-taught passion for art and has been a professional artist for the past fifteen years. Despite facing life-changing orthopedic challenges, Ardith holds true to her faith and the belief that no matter what challenge life throws her way, nothing will quench her spirit to continue creating, sharing and inspiring. With joyful determination, she shares her love of art with children and adults through local and online classes, and she actively promotes the lifestyle of moving through life as a creative maker.

Ardith is also one of the art specialists at St. Paul's Episcopal School in Mobile, Alabama, teaching students in third through eighth grades.

"My paintings and writings are my way of taking that courageous spirit, mixing it in with an insane love of mark making, color, and oddness, and creating works of art that inspire others to see the world as intrinsically beautiful no matter their place or station in life," Ardith says. "My hope is that through my marks and my practice, my work will resonate with the viewers so that they sense a connection to the way of life in the South; i.e., its geographical influence and the myriad of colors and marks that make being a Southern artist magical."

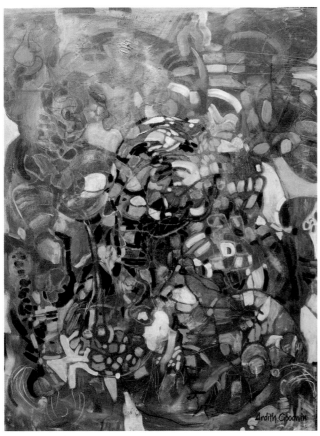

WE ARE STRONGER THAN WE KNOW
36" × 48" (91cm × 122cm), acrylic on canvas

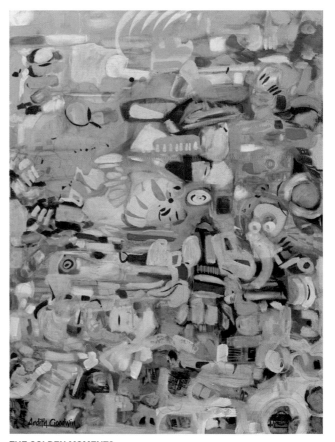

THE GOLDEN MOMENTS
36" × 48" (91cm × 122cm), acrylic on canvas

Resources

A SPECIAL THANK-YOU to the following companies that supported many of the projects and art created throughout this book. Your generosity helped make this project become a reality!

Many of the products used throughout the book can be found at any number of art supply stores. Please support your local retailer whenever possible. In addition, you can find a wide array of art supplies online:

http://www.jerrysartarama.com/
http://www.dickblick.com/

Ampersand
Makers of high-quality Harbord, Gessobord and Claybord surfaces used in several of the projects in this book.
http://www.ampersandart.com/

Grafix Arts
Manufacturers of the Dura-Lar paper and transparencies, mono printing plate and inking plates used throughout the chapters.
http://www.grafixarts.com/

Golden Paints
Offering some of the finest professional acrylic paints available on the market. Their rich pigments have been lovingly brushed, splashed and splattered on all of my paintings in this book.
http://www.goldenpaints.com/

Index

a content + ecommerce company

20 19 18 17 16 5 4 3 2 1

Distributed in Canada by Fraser Direct
100 Armstrong Avenue
Georgetown, ON, Canada L7G 5S4
Tel: (905) 877-4411

Distributed in the U.K. and Europe
by F&W Media International LTD
Brunel House, Forde Close, Newton Abbot, TQ12 4PU, UK
Tel: (+44) 1626 323200, Fax: (+44) 1626 323319
Email: enquiries@fwmedia.com

ISBN 13: 978-1-4403-4652-1

Edited by Beth Erikson
Designed by Clare Finney
Production coordinated by Jennifer Bass

Metric Conversion Chart

To convert	to	multiply by
Inches	Centimeters	2.54
Centimeters	Inches	0.4
Feet	Centimeters	30.5
Centimeters	Feet	0.03
Yards	Meters	0.9
Meters	Yards	1.1

About the Author

Jodi Ohl is a self-taught mixed-media artist, originally from
Dunkirk, New York, who now resides in Aberdeen, North
Carolina. Having recently left her day job to pursue her artistic
career full time, she has built a body of work that is known for
its distinctive texture and bold color combinations. Her pieces
are often whimsical or abstract and motivational in nature. Her
art appeals to those who are young at heart and who appreciate
the positive side of life whether communicated through words,
colors or composition.

Jodi's work has been published in over twenty-six
international mixed-media magazines, such as *Cloth Paper
Scissors, Somerset Studio, Artful Blogging, Artful Journaling,
Somerset Holidays and Celebrations* and *Cloth Paper Scissors
Studios*, as well as six mixed-media books. For three years in
a row, her paintings have been featured in the curated books
showcasing the best of mixed-media, *Incite 2, 3* and *4*. Jodi
enjoys writing about her art and sharing the love of healing and
motivation through creativity. She is represented by regional
galleries in North Carolina and several others throughout the
East Coast. In addition, Jodi is a popular mixed-media art
teacher online and in person, teaching at both large and small
local and national workshops around the United States.

When not painting, she enjoys time with her two sons, Josh
(15) and Zach (21), as well as other friends and family. Jodi also
has several instructional DVDs offered by North Light available
in the Interweave store. Stop by her blog, Sweet Repeats
www.sweetrepeats.blogspot.com to find a full listing of classes,
weekly musings and additional artwork for sale.

Dedication

I dedicate this book to my loving and ever supportive mother. From day one, she has been there to cheer me on and encourage me in every way possible. From her, I have learned so much about life, integrity, work ethic and how to overcome obstacles. Her belief in me has given me the guiding force and confidence to pursue any dream I believe in. Thank you, Mom. I'm grateful for it all.

Acknowledgments

I want to start my thank-you with my boys, who have tolerated me during moments of chaos in our house as I prepared all the art and projects for the book and who have allowed me to pursue my dream without complaining about the time spent away from them.

To my beloved family and friends, whom I'm so fortunate to have in my life: It was your encouragement and advice that kept me moving forward even during times when the project seemed overwhelming.

To my dear students, thank you for your long-time support and encouragement. Your cheerleading from the sidelines and your loyalty have propelled me to reach for greater heights in my work. Thank you for trusting in me as I guide you through these lessons and beyond.

To my editor, Beth Erikson, whose patience and thoughtful guidance kept me inspired and balanced. Thank you for all of your efforts to create the best book possible and all the direction you offered along the way. To Christine Polomsky, our photographer, who made the making of the book so personal and fun! And to Tonia Jenny, who first believed in me and helped to make this dream come true.

For all of the people at F+W Media who worked behind-the-scenes on this book, I thank you from the bottom of my heart. You have truly helped to create a bucket-list moment!

A big thank-you to my guest artists who so graciously shared their talent with us—you are so appreciated!

Ideas. Instruction. Inspiration.

Receive FREE downloadable bonus materials when you sign up
for our free newsletter at artistsnetwork.com/Newsletter_Thanks.

Find the latest issues of *The Artist's Magazine*
on newsstands, or visit artistsnetwork.com.

These and other fine North Light products
are available at your favorite art & craft
retailer, bookstore or online supplier. Visit
our websites at artistsnetwork.com and
artistsnetwork.tv.

Follow North Light Books for the latest news,
free wallpapers, free demos and chances to
win FREE BOOKS!

Visit artistsnetwork.com and get Jen's North Light Picks!

Get free step-by-step demonstrations along with
reviews of the latest books, videos and downloads
from Jennifer Lepore, Senior Editor and Online
Education Manager at North Light Books.

Get involved

Learn from the experts. Join the conversation on